IMAGES
of America

BOEING FIELD

IMAGES
of America

BOEING FIELD

Cory Graff

ARCADIA
PUBLISHING

Published by Arcadia Publishing
Charleston, South Carolina

Printed in the United States of America

Library of Congress Catalog Card Number: 2007935833

For all general information contact Arcadia Publishing at:
Telephone 843-853-2070
Fax 843-853-0044
E-mail sales@arcadiapublishing.com
For customer service and orders:
Toll-Free 1-888-313-2665

Visit us on the Internet at www.arcadiapublishing.com

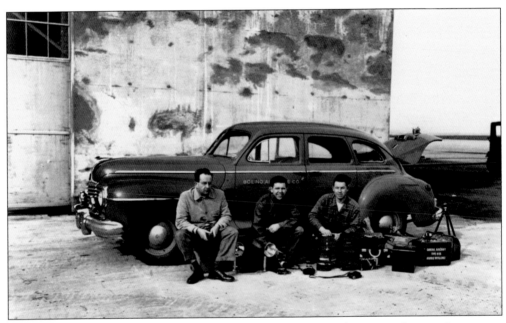

This book is dedicated to The Boeing Company photographers who, over the years, captured almost every activity and aircraft on Boeing Field. (Photograph by The Boeing Company; reprinted with permission by The Museum of Flight.)

CONTENTS

ACKNOWLEDGMENTS

Special thanks to P. J. Muller, Katherine Williams, Bob McCall, Shawn Chamberlain, Janice Baker, Shauna Simon, Dennis Parks, Steve Ellis, Joe Walker, Bob Dempster, Robert W. Ellis, and Ed Davies. These people helped me with their images, advice, expertise, and gracious support. Thanks to those working in local institutions who offered their valuable assistance—Janette Gomes of the King County Archives, Carolyn Marr from the Museum of History and Industry, Nancy Sheckler-Cecchi and Peter Anderson at Galvin Flying Services, Tom Lubbesmeyer and Michael Lombardi from The Boeing Company Archives, and King County International Airport's (KCIA) Rita Creighton. And thanks to those who saw fit to donate their valuable collections to The Museum of Flight—Peter Bowers, Louis Marsh, George Martin, Elliott Merrill, Clayton Scott, Elsie Anderson, Jim Dilonardo, and Jules Verne Hyde. Finally, thanks to Julie Albright of Arcadia Publishing.

INTRODUCTION

On the spot where the runways of Boeing Field (King County International Airport) lie today, some of the first settlers in the area made their land claims. Before the famous Denny party arrived on Elliott Bay's Alki Point in late 1851, four men made their way down the curving Duwamish River to find the most desirable locality in the region to build their homesteads.

On September 16, 1851, Luther Collins, Henry Van Asselt, Jacob Maple, and Maple's son Samuel were the first to file Donation Land Claims—making them the first whites to settle in what would become King County and in what is now the city of Seattle.

The Denny party, arriving a week and a half later, settled at Alki before parts of the new community moved to the east side of Elliott Bay to the area that is today downtown Seattle.

Collins, Van Asselt, and Maple are often just a side note in the history books, if they get any credit at all. Their claims were considered outside the city proper. Indeed, the Georgetown area, south of Seattle, was not assimilated into what was then called the Queen City of the Pacific Northwest until 1910.

By then, it is doubtful that any of the first settlers would have recognized their homes. Much of the land was being cleared and planted, with farms cropping up everywhere to take advantage of the rich soil deposited by the meandering Duwamish River.

A strange scene in this landscape was "the Meadows" resort—a whitewashed hotel, a boardwalk, and a mile-long horse racing track nestled into one of the river's long oxbow curves. On race days, spectators came in droves to the impressive 10,000-person grandstand. Many race fans rode down the railroad tracks from Seattle in open-topped cattle cars.

On August 12, 1905, the horses gave way to automobiles and motorcycles for the day. "Contrary to expectations," reported the *Seattle Post-Intelligencer*, "no one was killed and only one injured." The next logical step, it seemed, was "aeroplanes."

Charles K. Hamilton came to town on March 11, 1910, and unpacked his Curtiss biplane at the Meadows. Hamilton, known as the "Crazy Man of the Air," and his noisy, rickety machine attracted 20,000 people. During one performance, Hamilton crashed into the pond at the center of the infield, but he was back the following day. However, his waterlogged engine would not start, and Seattle spectators went home unsatisfied. He was back in the skies the next day, offering two free shows.

J. Clifford "Cliff" Turpin's visit went even worse. During a May 29, 1912, performance, Turpin lost control of his airplane and crashed into the packed Meadows grandstand. Though Turpin was unhurt, 21 spectators were injured, and one person was killed.

Elsewhere in Seattle, others were thinking more broadly about the merits of flying. William Boeing, a lumber baron, took a great interest in aviation. After attending a large flying meet in Los Angeles, he convinced a Seattle-based pilot to take him for a ride. He then took flying lessons, purchased a Martin trainer, and, with a partner, began to make his own aircraft.

Boeing's company really got rolling when he received an order from the U.S. Navy to build floatplanes in 1917. To construct the 50 aircraft ordered, Boeing moved into a former shipyard building downriver (north) of the Meadows site. From then onward, the Boeing Airplane Company "took off," even weathering the hard times after World War I by making wooden furniture, boats, and revamping older aircraft.

While most of Boeing's early planes were equipped to land on water, later aircraft, both civilian and military, were landplanes. This presented a problem for Boeing. His factory was isolated on a plot of mushy land. The aircraft had to be built, disassembled, and moved to Sand Point, Camp Lewis, or a nearby patch of vacant ground. There the planes had to be reassembled by Boeing's small workforce, test flown, taken apart again, packed, and shipped by train or truck to their final destination. It was an involved process, to say the least.

In the 1920s, local government was straightening the Duwamish River with dredging and filling. Boeing's desires for a new aviation field amid the valley's sprawling truck farms coincided with the city and county's plans to do the same for Seattle's growing population base.

King County condemned farmer's shacks and plots of land south of the Georgetown area for its new airport. Eighteen feet of fill over the Duwamish flood plain, topped with cinders, was dubbed Boeing Field. The opening ceremonies took place on July 26, 1928, with more than 50,000 people in attendance.

Boeing Field officials asked the U.S. Army, Navy, and Marine Corps; the Boeing Airplane Company; and many commercial aviation outfits to bring their flying machines to the event. The mayors of every city in Washington, along with officials from Oregon and British Columbia, were also invited to attend.

Among those speaking at the dedication were Gov. Thomas B. Stimson, Mayor Frank Edwards, and, of course, William Boeing himself. During the ceremony, a plaque was unveiled that said, in part, "Boeing Field. Acquired by the people of King County, State of Washington, for the purpose of promoting aeronautics and named in honor of William Edward Boeing, whose intelligent, active, and long continued interest in all that concerns and advances the science of aeronautics merits and receives the public gratitude." This plaque can still be seen outside the terminal building on the airport's east side.

Two weeks later, the first of countless noise complaints was lodged against aviators using the field. A man on Orcas Street claimed that his hens had stopped laying eggs because of the low-flying planes. Similar objections about airplane noise are still heard by Boeing Field's officials today.

Others complained too. While some aviators said that Boeing Field was the best airport they had ever seen, other pilots were perhaps more honest in their assessment. If a flyer made it over the hills, wires, and smokestacks, they joked, then he or she could try to line up to land on one of the field's incredibly short, muddy, puddle-pooled runways. When record-breaking pilot Louise Thaden winged in from Portland in 1929, she stated Boeing Field was one of the worst she had ever seen. She told the *Seattle Post-Intelligencer* the field was "a political airport"—small, poorly kept, and dangerous.

Grade A or bush league, Boeing Field was used extensively right from the start. Seattle had always been known as "a city that was a long way from anyplace," but the airport changed that. After opening day, the field was often filled with airplanes. Some of the first were airlines, carrying people and mail down the coast to California and up into Canada. West Coast Air Transport (WCAT), which operated three-engine Bach Air Yachts, and Pacific Air Transport (PAT), flying Boeing Model 40 mail planes, were two of the biggest.

To carry more passengers, both switched to bigger aircraft as the air travel business grew. PAT became part of United Aircraft and Transport Corporation (UATC) in 1929 and then took over WCAT in 1931.

UATC was growing into an industrial powerhouse. The components of the huge business machine included aircraft builders such as Seattle's Boeing Airplane Company, as well as Chance-Vought, Stearman, and Sikorsky, aircraft components suppliers such as Pratt and Whitney, and Hamilton Standard, and airlines including Boeing Air Transport, National Air Transport Varney Air Lines, and Pacific Air Transport (all under the banner United Air Lines).

United Air Lines was the dominant force in all things aeronautical, and Boeing was the big fish in the small pond at Boeing Field. The company's new mail planes and military fighters buzzed in and out with growing regularity.

But Boeing's aircraft building plant was still isolated. It led to rumblings that Boeing would move to California for cheap land just a stone's throw from a ready runway. The fact that Boeing

was now part of UATC, a much bigger organization, made the company's local connections all the more tenuous.

Earth-shaking changes came in 1934, when the huge holding company was broken up by the U.S. government. Boeing was one of three large pieces to come out of the end of UATC. William Boeing was so angry over the destruction of the United Air Lines empire that he chose to retire. When new president Claire Egtvedt wanted to build larger, four-engine metal aircraft, the Boeing Airplane Company's location problem grew even more acute.

It was an immigrant truck farmer who convinced Boeing to stay in Washington State by selling the company his land on the west side of Boeing Field for $1. The generosity of Guisseppe Desimone allowed the company to construct its second airplane-building plant adjacent to the runways.

Plant No. 2 started out small—with room for nine good-sized planes. Model 307 Stratoliner passenger planes and B-17 bombers were the first to be rolled out of the doors onto the rainy tarmac. Both famous aircraft made their first flights from Boeing Field. With fighting in Europe, Boeing's Plant No. 2 expanded greatly, making bombers for America's allies.

It was clear to most that war was on the way for America too. The airport was paved in 1941 with the help of a $223,000 defense appropriation. Boeing Field was closed to all civilian air traffic on December 6, 1941. The next day, Pearl Harbor was bombed. The country's entrance into war changed many things at Boeing; suddenly, the army wanted every bomber the company could build and more.

As young men went overseas, the company had to tap into previously ignored segments of the population. Women were recruited in huge numbers, at one point making up 49 percent of Boeing's bomber-building workforce.

Their output was amazing—at the height of production, 16 giant four-engine B-17 Flying Fortress aircraft were rolled across East Marginal Way South onto Boeing Field every work day. Around that time, Seattle employment at the aircraft giant peaked at more than 44,000 workers.

The importance of West Coast aircraft-building factories led the government to order them camouflaged. It was a tall order. How do you hide a 750,000-square-foot building? Boeing workers constructed an entire artificial neighborhood on the roof. It was hoped that any Japanese attack would focus on the industrial buildings a few blocks south, leaving Plant No. 2 safely hidden as it churned out vital war machines.

While those bombers were fighting it out with the Germans and Japanese overseas, Boeing was busy with its next creations. The bigger, faster B-29 Superfortress took off from Boeing Field for the first time on September 21, 1942, with chief test pilot Eddie Allen at the controls.

The B-29 was a difficult bird, plagued with growing pains that included reoccurring fires. On February 18, 1943, one of the first airplanes was lost during testing. Struggling to make it back to Boeing Field with a wing ablaze, the big bomber crashed into the Frye & Company meat packing plant a few miles to the north. The crash killed Allen and his entire crew, as well as many on the ground.

Even with the loss, the Superfortress program continued. Boeing's B-17s were the cornerstone of the aerial war effort in Europe, and the B-29s brought about the surrender of the Japanese.

After World War II, the airlines returned to Boeing Field, but things had changed. With nowhere to go while the airport was run by the military, much of the civilian air traffic had moved slightly south and west to a spot developed by the Port of Seattle. Seattle Tacoma International Airport's first scheduled flights took off in 1947. In the years afterwards, United, Northwest, Pacific Northern Airlines, and Pan Am flights forever changed their airport code from BFI to SEA.

It was the beginning of Boeing Field's reputation as "the schizophrenic airport." In the post-war years, the still-busy field handled a varied hodgepodge of small private planes, business flights, repair and teaching facilities, cargo planes, helicopters, and Boeing's behemoths. The promotional brochures for the field claimed it served "Everything 'Aviational.' " The airport's proximity to downtown made it the choice for many high-powered executives, movie stars, sports heroes, generals, and presidents.

Of course, Boeing was still the top dog, and bombers and their support aircraft were still primary moneymakers in the Cold War world. A joke that made the rounds among military flyers was

that the U.S. Air Force's acronym, SAC (Strategic Air Command), actually stood for Seattle's Air Command, based at Boeing Field.

In 1947, an updated version of the Superfortress, a new tanker plane, and a sleek jet bomber inspired by captured Nazi documents all made their debut. The B-47 was a milestone aircraft. After the Stratojet roared into the skies, nearly every American-built jet airplane was roughly based on its highly successful design.

In 1951, the king of all the bombers rolled out of Plant No. 2. To hide the prototype B-52 Stratofortress from the prying eyes of the public, the monster plane was towed onto the field in the dead of night, shrouded in yards of white tarpaulins. To accommodate the bigger jets, the field's main runway was extended to the south, making its total length 10,000 feet.

In the 1960s, a majority of Boeing's airplane-building work moved elsewhere, but the airport that bore the company founder's name was still alive with Boeing's aircraft. Boeing's flight test center, military ramp, delivery facilities, developmental center, wind tunnel, and a paint shop remained on the Seattle site.

In the 1970s, Boeing's battered Red Barn, its first airplane-building factory, was barged up the Duwamish River to the southwest corner of Boeing Field. The Museum of Flight opened the restored building to the public in 1983. With major expansions in 1987 and 2004, the museum today holds a vast collection of air and space craft, including the first jet Air Force One, a Concorde supersonic airliner, and a Blackbird spy plane.

After 80 years, the story of Boeing Field continues. Even with the major airlines gone, the airfield still handles 300,000 takeoffs and landings each year—an average of more than 800 a day. The airport is currently home to more than 150 businesses, including air taxi services, flight schools, and air cargo operators. It is also the home base for hundreds of private and executive aircraft.

Aviation enthusiasts continue to be drawn to the airfield too. They anxiously wait at the fences, their cameras in hand. Boeing Field is one of their favorite places because "You never know what's coming next."

One

THE BEGINNINGS

For thousands of years before settlers arrived, the Duwamish River meandered through a flat plain on its way to Elliott Bay in Puget Sound. The east boundary of present-day Boeing Field is located along the railroad line seen in quadrants 28 and 33 at the lower left-hand corner of this 1853 map. The Meadows Racetrack, built in 1902, was nestled in the large oxbow seen below the numeral 33. (The Museum of Flight.)

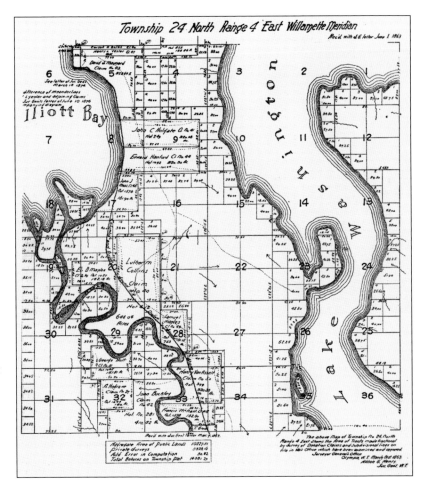

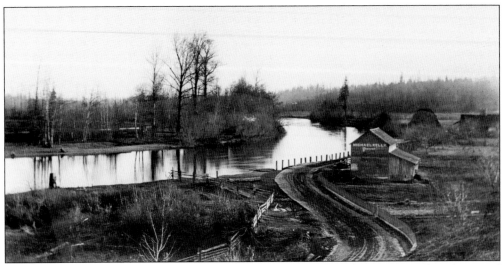

For years after the first settlement of the Duwamish River Valley, the area was a broad pastoral landscape dotted with simple homesteads and farms. Michael and Jane Kelly were among those who began farming in the rich soil deposited by the river. They came to the area in the early 1870s. This image of their homestead was taken in the 1890s. (Museum of History and Industry.)

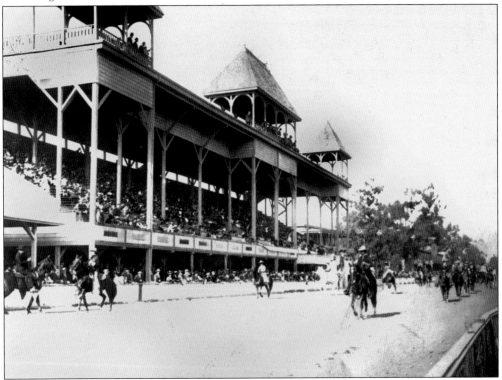

The Meadows area was a resort with a whitewashed hotel, boardwalk, and a horse racing track that boasted a one-mile dirt oval and an elaborate grandstand for race fans. The four-legged racers and their jockeys seen in this 1902 photograph gave way to wheeled machines three years later when the track was host to automobile and motorcycle races—the first in the Pacific Northwest. (Author's collection.)

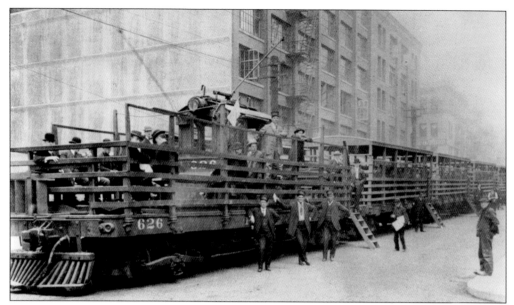

Fans crowd onto cattle cars in downtown Seattle for a short trip down the rails to a "day at the races." The Meadows horse races attracted thousands of spectators during the short summer season. When conditions were right, the Meadows was considered one of the fastest race venues in the country. The area south of the city of Seattle, beyond city limits and out of the reach of officials, was a haven for gambling, unregulated saloons, and brothels in the early 1900s. (Museum of History and Industry.)

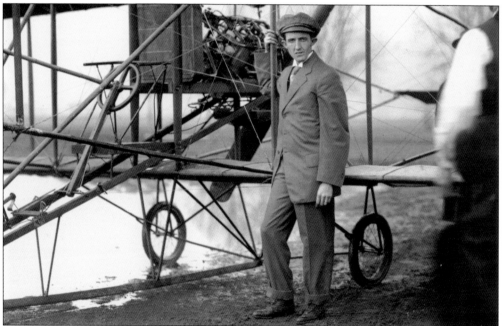

Called the "Crazy Man of the Air" in Seattle's newspapers, flyer Charles Hamilton drew a crowd of more than 20,000 at Meadows Racetrack in 1910. The price to see Hamilton's stunts, dives, and race with an automobile was $1 for adults and 25¢ for children under the age of 12. (Museum of History and Industry.)

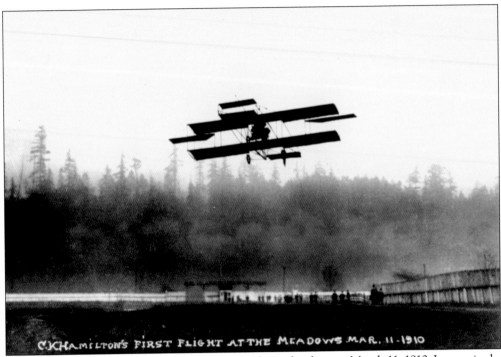

C.K.HAMILTON'S FIRST FLIGHT AT THE MEADOWS MAR. 11-1910

Charles Hamilton and his Curtiss Reims Racer take to the skies on March 11, 1910. Interestingly, this first airplane flight in Washington State took place on the very spot where Boeing Field's runways would one day stand. (The Museum of Flight.)

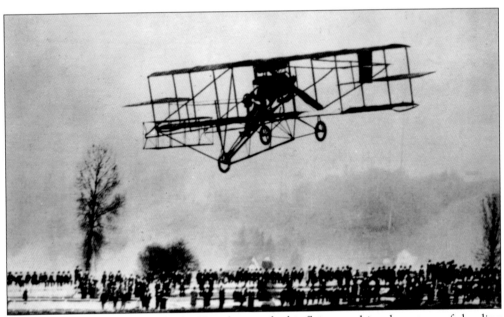

Over hundreds of onlookers, Charles Hamilton guides his flying machine down to a safe landing on the dirt track in front of the Meadows grandstand. Note how the elevators, out in front of the aircraft, are canted upward to arrest the airplane's steep descent. (The Museum of Flight.)

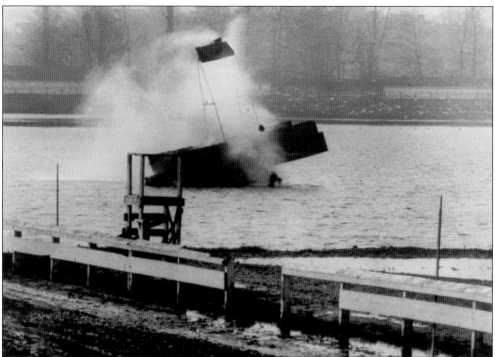

Charles Hamilton's final show on the first day ended slightly early. During his patented dive, a maneuver that today would be called a stall, his Curtiss biplane splashed into the pond in the middle of the racetrack. Neither he nor his airplane were seriously hurt in the crash, but the airplane's engine would not start the following day. Hamilton came back on Monday and flew two free shows. (The Museum of Flight.)

After Charles Hamilton's crash, there was some doubt as to whether he would fly again, which, of course, was not good for business. Handbills and newspaper advertisements like this one appeared around Seattle to encourage people to go down to the Meadows for the show. In fact, the advertisement even seems to insinuate that the spectators might get to see another crash. (King County Archives.)

Will Fly Again Today

HAMILTON

The Crazy Man of the Air, Is Ready for More Sensational Flights and His Race With an Automobile

Notwithstanding injuries received in yesterday's closing dip to the ground, and the fact that he declares the course dangerous, the king of the bird men will attempt to achieve greater fame by making more dangerous plunges through the air.

Both Today and Tomorrow

General Admission $1; Children Under 12 Years 25 Cents

Northern Pacific Special Trains from the Union Depot every half hour, beginning at noon.

Interurban Trains from First Avenue and Main Street every ten minutes, beginning at noon.

Gates Open at Noon═First Flight at 2:15

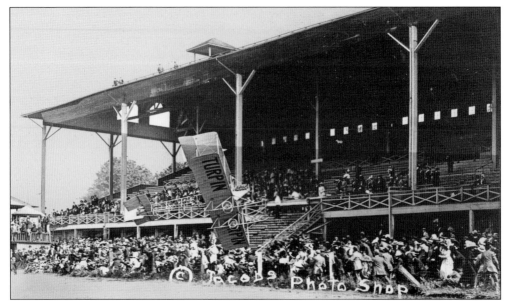

Some aerial exhibitions turned out worse than Charles Hamilton's crash. On May 29, 1912, J. Clifford "Cliff" Turpin lost control of his biplane and careened into the Meadows Racetrack grandstand. Here the aircraft is photographed moments before the collision as the crowd scatters. Turpin was unhurt, but the crash killed one spectator and injured 21 others. After this accident and the death of his exhibition partner just three days later, Turpin gave up flying for good to sell Glide automobiles for the Bartholomew Motor Car Company. (The Museum of Flight.)

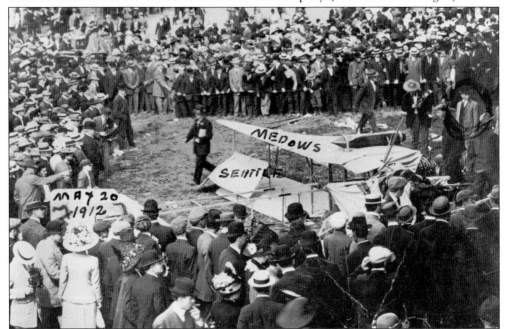

The caption writer got the date wrong (and missed a letter in Meadows), but this interesting image shows the crowds circling what is left of Cliff Turpin's smashed Fowler Gage tractor airplane after it "fell out of the air" in May 1912. The crash brought about Seattle's first aviation fatality—a spectator at the air show. (Museum of History and Industry.)

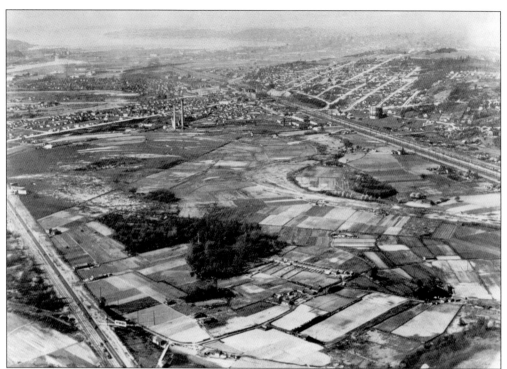

The future site of Boeing Field can be seen in this 1920 photograph. The gas storage tank and smokestacks of the Georgetown steam plant would be at the north end of the airport-to-be. The 1911 "Plan for Seattle" included the straightening of the Duwamish River. The remains of the twisting former riverbed can be seen curving along on the right side of the image. (The Museum of Flight.)

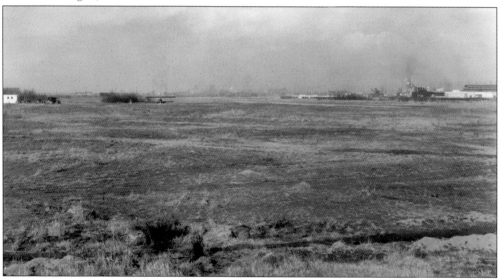

Arguments still rage as to who was the first to land at Boeing Field. Photographs like this one, taken in 1927, only muddy the already clouded waters. It proves what many old timers already knew—even before there were runways, pilots used the open area south of Seattle as a landing field. (Museum of History and Industry.)

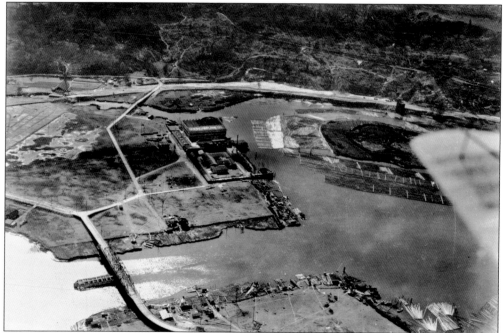

Farther north (downriver) on the Duwamish River, the Boeing Airplane Company's Plant No. 1 complex was developed without a runway. William Boeing acquired the former boat-building site in 1910. In 1917, he began filling U.S. Navy orders for floatplane trainers. The large brick building seen on the site was constructed in 1918. Later aircraft, built with wheels, were sometimes shipped to nearby patches of vacant land for test flights. (Photograph by The Boeing Company; reprinted with permission by The Museum of Flight.)

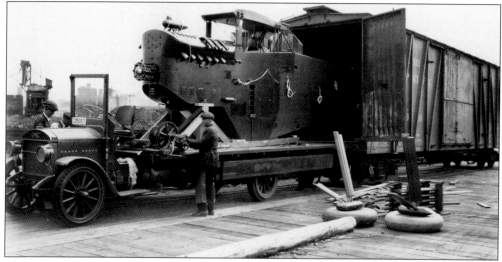

The reason the creation of Boeing Field was so important to William Boeing's company can be seen in this photograph. Aircraft built at the isolated Plant No. 1 had to be assembled during construction, taken apart, transported to an airfield, reassembled, test flown, taken apart again, and finally moved to the waiting customer. When the product was something like this GA-2 armored attack plane, it was a formidable task that took many days. (Photograph by The Boeing Company; reprinted with permission by The Museum of Flight.)

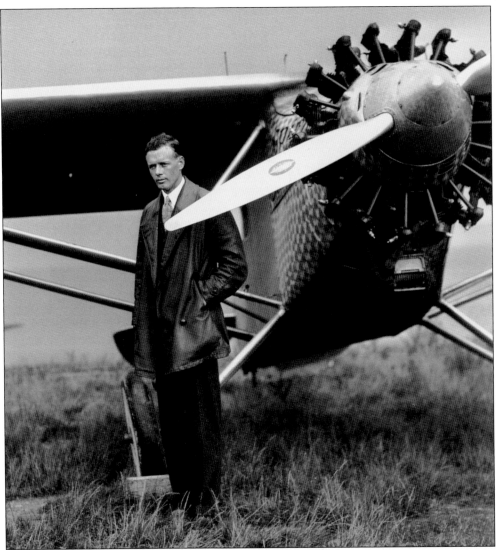

A little shame can go a long way. After Charles Lindbergh completed his famous New York–to–Paris flight, He toured the United States, promoting aviation. He had a habit of asking local officials, "So, this is your airport?" He may have done the same when he touched down at Sand Point, a few miles northeast of downtown Seattle, on the shores of Lake Washington on September 13, 1927. "Shame airports," as they were called by some historians, were hastily built by many cities around America after Lindbergh's tour; Boeing Field was among them. (Museum of History and Industry.)

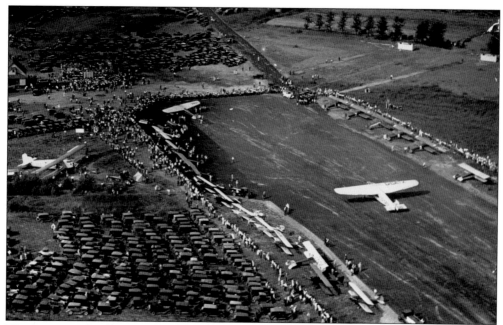

The 444 acres for the airport were acquired in 1928, and King County's dedication ceremony took place on July 26, 1928. More than 50,000 people were in attendance for Boeing Field's first day. Many aircraft were flown in, including some U.S. Navy aircraft from Sand Point. On the left side of the photograph, Boeing's new Model 80 can be seen. The three-engine passenger biplane flew for the first time the following day. (The Museum of Flight.)

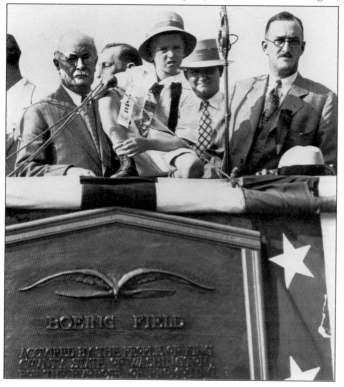

William Boeing (right) was in attendance for the dedication of the airfield that would be named in his honor. The young boy is William "Bill' Boeing Jr. When asked what he remembered about the momentous day, Bill stated that his job was to pull back the banner covering the dedication plaque. He recalls that his precarious perch seemed awfully high up. (Photograph by The Boeing Company; reprinted with permission by The Museum of Flight.)

Two

THE GOLDEN AGE

The airport's first manager was Jules Verne Hyde, a former U.S. Army pilot who had served as flight commander at Brooks Field, Texas, until the end of World War I. In the early 1920s, Hyde became an exhibition flyer and barnstormer. He winged into Seattle from Florida in early 1927, looking to further his aviation career. (The Museum of Flight.)

Historians are confused about who was the first to officially land and take off from Boeing Field. One man who is always mentioned is A. Elliott Merrill, a military pilot who, while in the reserves, established Washington Aviation (later called Washington Aircraft and Transport) at Boeing Field. When World War II came, Merrill was asked to join Boeing's flight test group. (The Museum of Flight.)

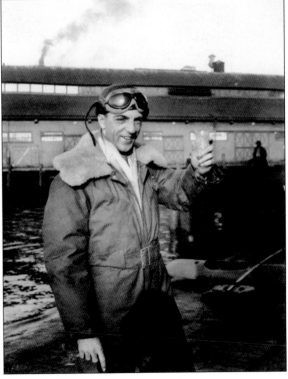

The other man who shares the honors for the first to land on the field was Clayton "Scotty" Scott, a commercial pilot who had his hand in many flying ventures, including delivering mail and passengers, racing, and exploring. Scott became William Boeing's personal pilot and, like Merrill, joined Boeing's test flying corps during World War II. He was said to have flown more B-17 bombers than any other man in the world. (The Museum of Flight.)

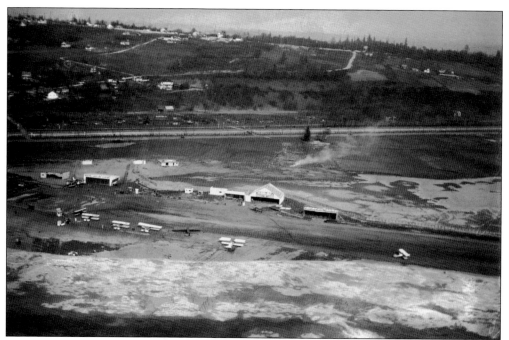

In its first days, Boeing Field was a fairly simple place with ramshackle buildings and basic hangars. The first administration building was described by some flyers as "an abandoned truck farmer's shack surrounded by mud." Boeing's first hangar on the site sits second from the left, a temporary tin structure. (Museum of History and Industry.)

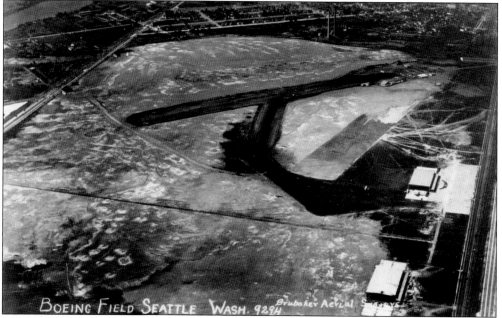

Along Duwamish Avenue (later called Airport Way), brick hangars for King County (above) and Boeing (below) sprang up fairly quickly after the opening. Most new construction took place along the avenue and railroad tracks. The buildings in the upper right corner were soon abandoned and eliminated as the field grew. (The Museum of Flight.)

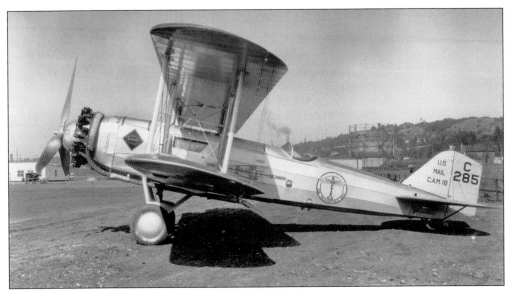

In the early years, Model 40 mail planes were a common sight buzzing in and out of Boeing Field. The airplane's powerful, air-cooled, Pratt & Whitney radial engine helped it heft hundreds of pounds of mail or, in some cases, passengers. Note the "B-Line" logo on the side of the fuselage. (Photograph by The Boeing Company; reprinted with permission by The Museum of Flight.)

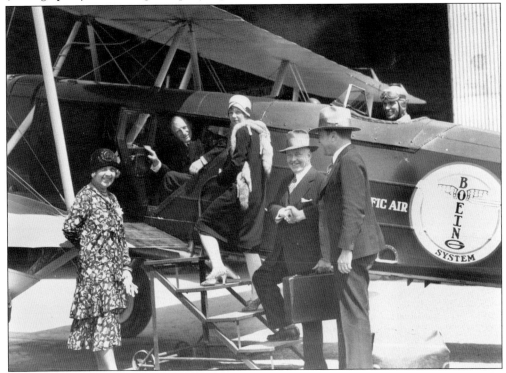

Riding in a Model 40 was not pleasant. It was usually a cold, bumpy, and cramped trip. At the time, mail was the focus, and passenger service was incidental. This Pacific Air Transport aircraft could get a stout soul from Seattle to Los Angeles for $125 in 1929. (Photograph by The Boeing Company; reprinted with permission by The Museum of Flight.)

Pacific Air Transport's operations manager Russ Cunningham was called "the dean of old airmail pilots" by the pilots of the era. Each star on his sleeve indicates 1,000 hours of flying time. On the back of this 1930 photograph, someone wrote, "What the well dressed pilot wears." In actuality, a pilot had to wear much more in the air than this or he would freeze. (Photograph by The Boeing Company; reprinted with permission by The Museum of Flight.)

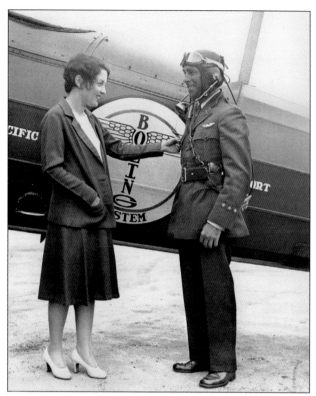

Imagine driving more than 100 miles per hour in a convertible on a cold, rainy winter night—that is what it was like to pilot a Model 40. The San Francisco–to–Chicago route took a flyer over some of the highest, coldest, and roughest country in the United States. (Photograph by The Boeing Company; reprinted with permission by The Museum of Flight.)

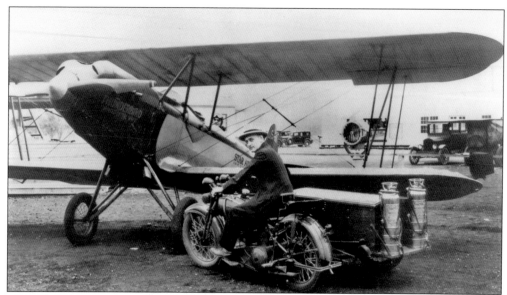

Here Jules Verne Hyde shows off one of the first vehicles purchased for the new airfield—a 1928 Harley Davidson motorcycle used for fire-and-crash rescues. The airplane in the background is a Thunderbird W-14 operated by Star Air Lines of Portland, Oregon. (The Museum of Flight.)

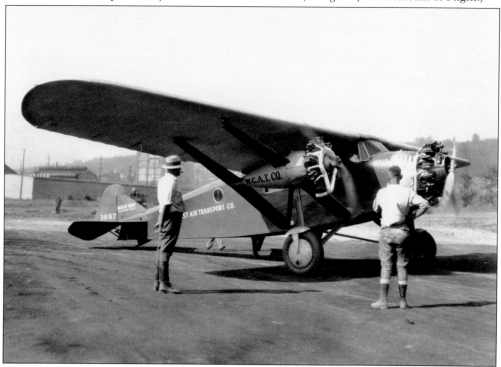

West Coast Air Transport flew Bach 3-CT-2 Air Yachts from Seattle to San Francisco. It cost $105 for a round trip. The running joke among the pilots was that the Wright Whirlwind engine in the nose of the eight-passenger plane actually pulled the aircraft along while the "semi-worthless" Ryan-Siemens engines on the wings were there simply to "cool the fuselage." (The Museum of Flight.)

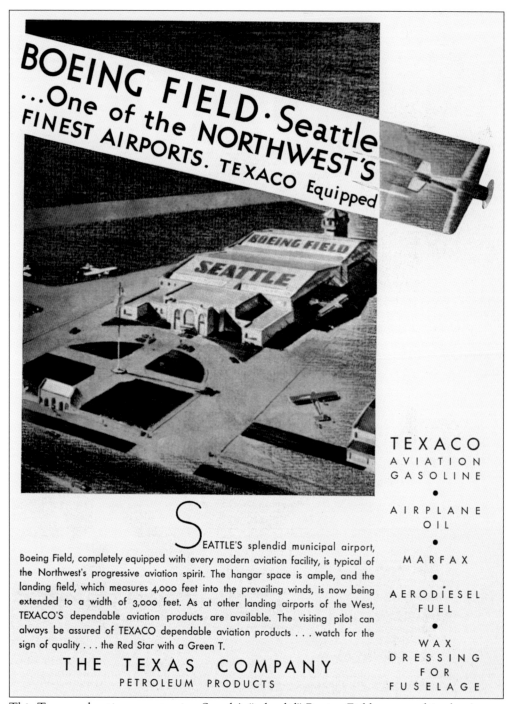

BOEING FIELD · Seattle
...One of the NORTHWEST'S
FINEST AIRPORTS. TEXACO Equipped

SEATTLE'S splendid municipal airport, Boeing Field, completely equipped with every modern aviation facility, is typical of the Northwest's progressive aviation spirit. The hangar space is ample, and the landing field, which measures 4,000 feet into the prevailing winds, is now being extended to a width of 3,000 feet. As at other landing airports of the West, TEXACO'S dependable aviation products are available. The visiting pilot can always be assured of TEXACO dependable aviation products . . . watch for the sign of quality . . . the Red Star with a Green T.

THE TEXAS COMPANY
PETROLEUM PRODUCTS

TEXACO
AVIATION
GASOLINE

•

AIRPLANE
OIL

•

MARFAX

•

AERODIESEL
FUEL

•

WAX
DRESSING
FOR
FUSELAGE

This Texaco advertisement, touting Seattle's "splendid" Boeing Field, appeared in the August 1930 issue of *Western Flyer* magazine. The hangars next to the administration building were a "yet-to-be-reality" and were never actually built. (The Museum of Flight.)

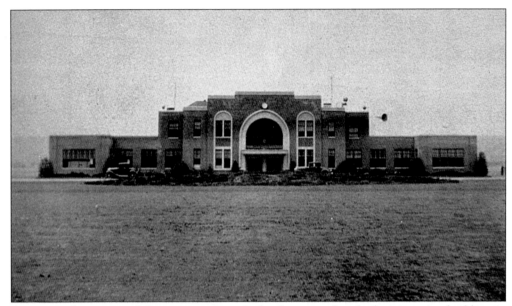

Airport leaders initiated the construction of a brick terminal and administration building in 1929 to replace "the shack." The handsome-looking new structure housed the general offices, a restaurant, control offices, a weather bureau, and a telegraph station. This photograph was taken before the new addition was officially dedicated. (The Museum of Flight.)

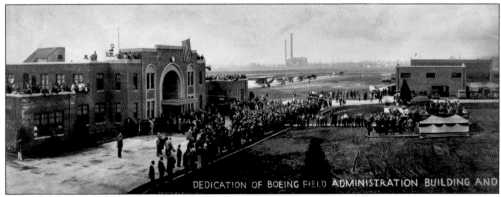

DEDICATION OF BOEING FIELD ADMINISTRATION BUILDING AND

In rainy Seattle, there is almost always mud. At the dedication of the administration and terminal building on April 21, 1930, attendees of the event stick to the paved areas and wooden walkways in this panoramic photograph taken from the two-story building next to the beautiful new terminal. (King County Archives.)

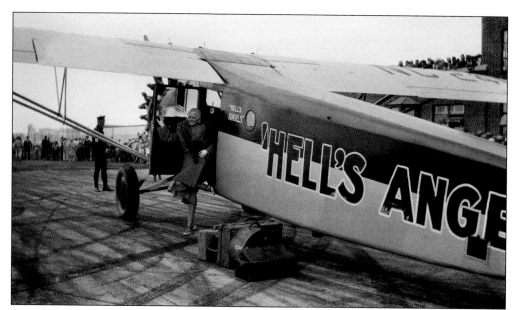

Crowds gather near Boeing Field's administration building to catch a glimpse of screen star Jean Harlow as she emerges from a brightly-painted Fairchild 71. She came to Seattle to promote Howard Hughes's 1930 aviation epic *Hell's Angels*. (The Museum of Flight.)

This hand-drawn plan view of Boeing Field comes from a 1930 air navigation map that carries depictions of airports in Oregon and Washington around its borders. The illustration shows the runways, beacons, and also the multitude of hazards surrounding the field— smokestacks, wires, and hills. (The Museum of Flight.)

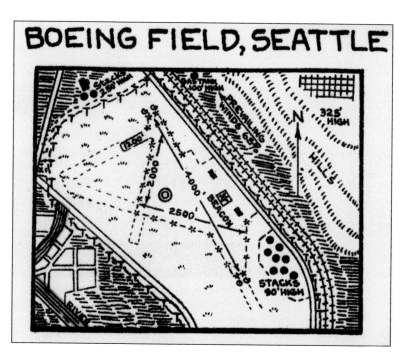

BOEING FIELD, SEATTLE

Due to the success of the Model 40's passenger-carrying flights, the Boeing Airplane Company looked to create planes specifically for carrying people. The Model 80 could seat 12 in the relative comfort of a large cabin, complete with forced-air ventilation, upholstered seats, and individual reading lamps. (Photograph by The Boeing Company; reprinted with permission by The Museum of Flight.)

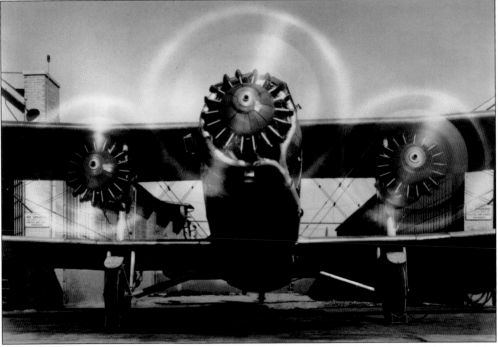

The big Model 80s were built specifically to fly the route from San Francisco to Chicago. The airplanes had powerful air-cooled engines, stout structures, and biplane wings to generate lift even at mile-high altitudes. (Photograph by The Boeing Company; reprinted with permission by The Museum of Flight.)

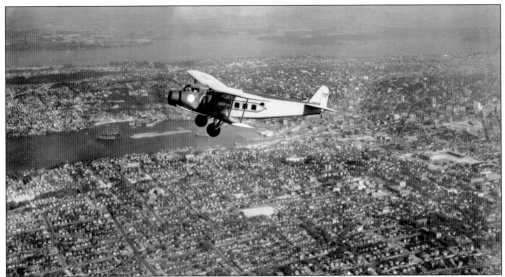

Seen here departing Boeing Field, a Model 80 cruises over the neighborhoods on Queen Anne Hill. Note the sailing ships anchored in Lake Union. Inside the luxurious passenger cabin, this "Pioneer Pullman of the Air" featured hot and cold running water in an honest-to-goodness bathroom. (Photograph by The Boeing Company; reprinted with permission by The Museum of Flight.)

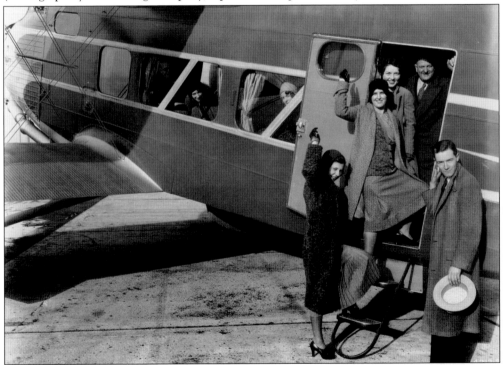

One of the original 80As was different enough to warrant a new designation—Model 226. The plane was built for the Standard Oil Company of California. The deluxe interior had an improved lavatory, enlarged windows, daybeds, overstuffed chairs, and a kitchen with a sink, a refrigerator, and a stove. The airplane was nicknamed the "Stanavo." (Photograph by The Boeing Company; reprinted with permission by The Museum of Flight.)

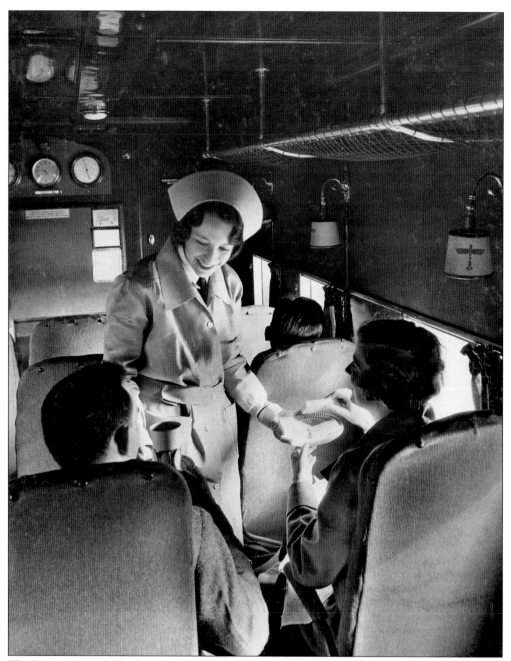

The Boeing 80s were the first aircraft to carry female stewardesses. Each one was a registered nurse, single, under 25 years of age, under 115 pounds, and less than 5-foot-4 inches tall. Originally, they were hired to calm passengers who had a fear of flying, but stewardesses soon proved to be an irreplaceable part of the air crew. Their jobs included the demanding tasks of hauling luggage, fueling planes, and helping to push the aircraft into the hangar at night. (Photograph by The Boeing Company; reprinted with permission by The Museum of Flight.)

Upgrading to larger passenger aircraft, West Coast Air Transport took on a fleet of Fokker F-10As. The airplanes departed Boeing Field daily at 8:30 a.m. and brought 12 air travelers along "The Route Picturesque" to arrive in San Francisco by 4:20 p.m. (The Museum of Flight.)

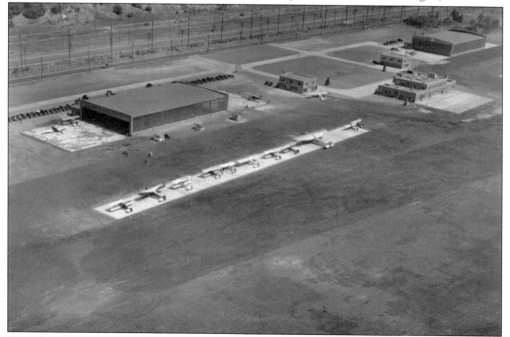

Here the general layout of the airport facilities can be seen looking southeast. The administration building and the pair of two-story brick structures that held the fire station and garage are in the center of the King County and Boeing hangars. Note the paved "warm-up pads" for aircraft. (The Museum of Flight.)

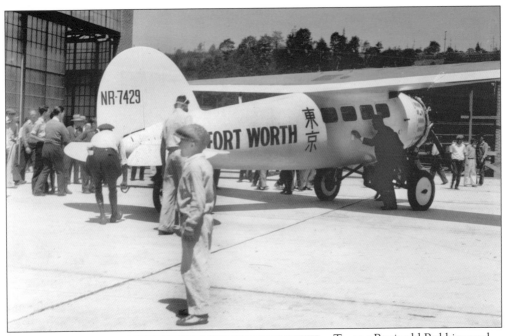

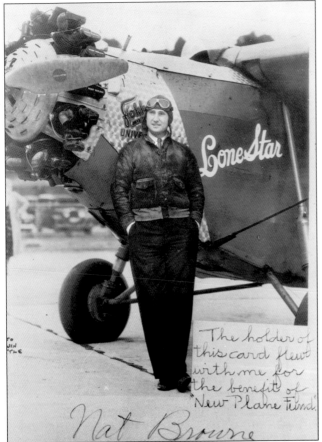

Texans Reginald Robbins and Harry Jones came to Seattle in the summer of 1931 in an attempt to fly their Lockheed Vega, named *Fort Worth*, from Boeing Field to Tokyo. After two tries, each with a different engine, the flyers only made it as far as Alaska. Disappointed, the airmen cruised back to Texas. (Robert W. Ellis.)

Nat Browne attempted to fly from Boeing Field to Tokyo in a heavily modified Fokker Universal he dubbed the *Lone Star*. Seattle citizens raised $29,950 as prize money for a successful crossing. After a broken oil line forced Browne to turn back on May 29, he readied his plane for another attempt the following day. (The Museum of Flight.)

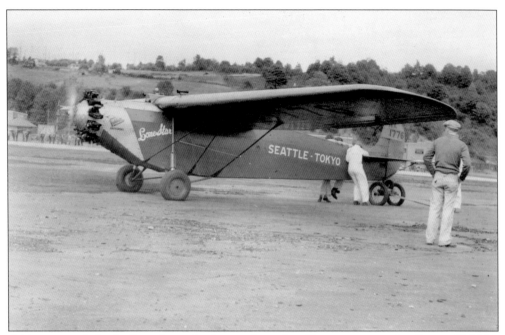

A big ramp to help the *Lone Star* gain the speed to take off was constructed at Boeing Field for Nat Browne's second record attempt. Browne would fly with a second man in the plane until a tricky in-flight refueling process with another airplane was completed over Puget Sound. Then the second crewman would parachute out, leaving Browne to fly the trip alone. At the beginning of the flight, everything went as planned. At the rendezvous with the fueling plane, the filler hose slapped into the tail of Browne's already delicate Fokker and caught. Structurally weakened in an attempt to save weight, the airplane came apart. Browne and his fueling partner were forced to jump. They were rescued by a speed boat cruising Puget Sound. All things considered, Browne was lucky—suffering only a dislocated shoulder and the loss of his airplane. (Both, The Museum of Flight.)

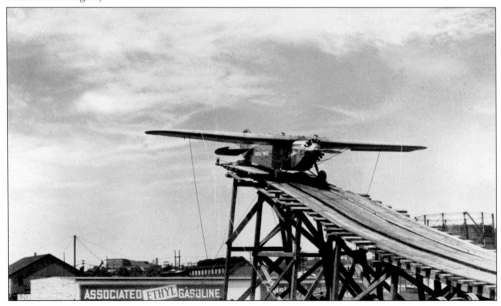

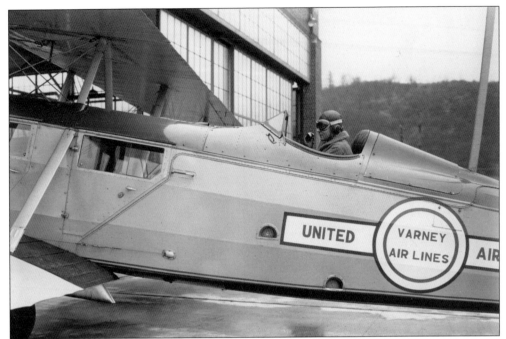

Under the direction of Thorp Hiscock, the Boeing Airplane Company perfected an airplane-to-ground voice radio in 1928. The technology, which overcame interference from the aircraft's ignition system and metal parts, was adopted by the entire air transportation industry. Note the tall radio mast installed on the Varney Air Lines Model 40B-4 in the photograph above. A room in Boeing Field's administration building completed the air-to-ground radio communication circuit. (Above, photograph by The Boeing Company; reprinted with permission by The Museum of Flight; below, Robert W. Ellis.)

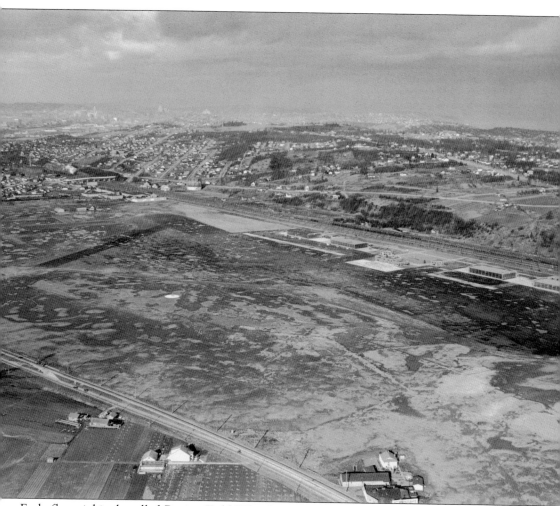

Early flyers jokingly called Boeing Field "The Swamp." The runway area, built on the former Duwamish riverbed, was just 10 feet above sea level and was covered with fill. At high tide, saltwater puddles appeared everywhere, making landings tricky. Pilots noted that the northern end of the field was particularly bad. (Museum of History and Industry.)

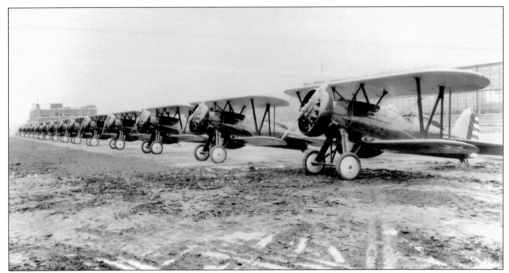

Today The Boeing Company is known for large, multi-engine machines, but the company used to be one of the best fighter-makers in America. From 1928 to 1933, Boeing built a series of highly successful, single-place biplane pursuits for both the army (designated the P-12) and the navy (designated the F4B). In this image, taken on the east side of the field, a group of new Boeing P-12E fighters awaits the arrival of army ferry pilots to begin their military careers. The line is so long that the plane in the foreground is parked in the wet slop at the end of the apron. The airplanes have factory-installed "Panama" headrests, which contained one-man rafts. (Photograph by The Boeing Company; reprinted with permission by The Museum of Flight.)

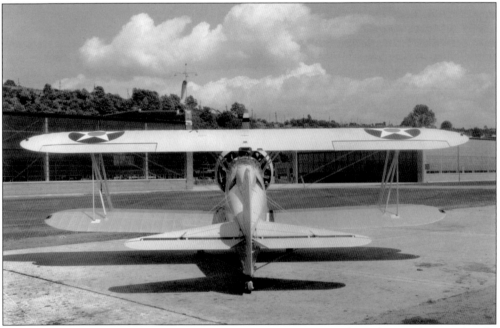

Boeing engineers often had ground crews pull a new aircraft from its parking place to photographically record it from various angles. The subject of this series, a navy F4B-1, was rolled to the edge of the paved surface and shot from all sides in July 1932. (Photograph by The Boeing Company; reprinted with permission by The Museum of Flight.)

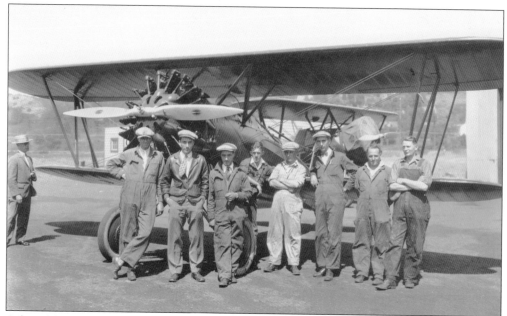

A few of the famous fighters were built for civilian buyers. Here the boys from the Boeing Airplane Company pose with the Model 100A, a special dual-seat aircraft built for Howard Hughes in mid-1929. Hughes used the plane as his personal runabout in the Los Angeles area, often flying alone. Over time, the 100A was heavily modified to make it a speedier racing airplane. (Photograph by The Boeing Company; reprinted with permission by The Museum of Flight.)

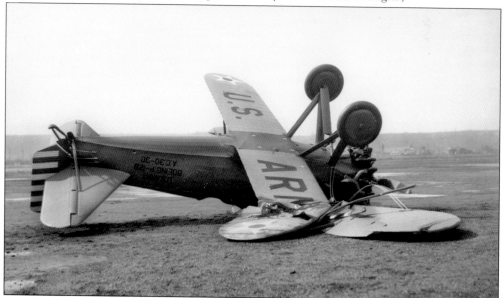

It was a bad day for this U.S. Army ferry pilot and an even worse one for this new P-12B, which has sustained heavy damage in its first minutes in the military. The Wasp engine is most likely wrecked, and the fighter's fabric-covered wooden wings are snapped through the spars. The fighter's stout, bolted-aluminum fuselage structure seems to have survived the impact. Amazingly, this aircraft was kept in the army's inventory after its March 22, 1930, crash to fly for 1,138 more hours. (Photograph by The Boeing Company; reprinted with permission by The Museum of Flight.)

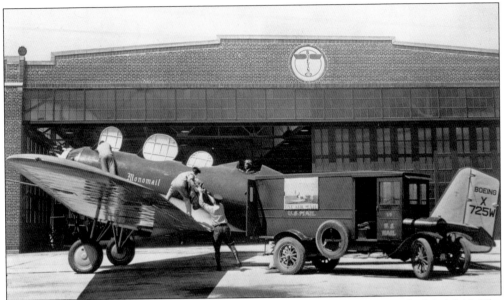

The Monomail was a mail and cargo plane built around the same engine as the Model 40. The sleek, all-metal aircraft was so ahead of its time that power plant and propeller makers could not keep up. The airplane needed a prop that was adjustable in flight, but none existed in 1930. By the time propeller technology caught up to the Boeing's aerodynamic marvel, the Monomail was already on the verge of being replaced with newer designs. (Photograph by The Boeing Company; reprinted with permission by The Museum of Flight.)

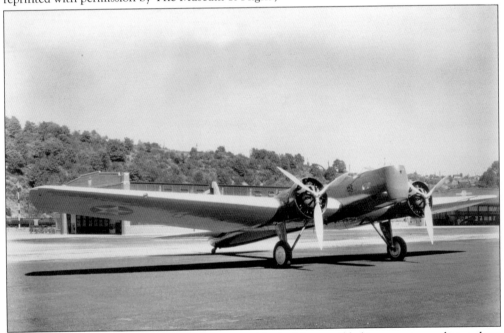

The Boeing Airplane Company's developments with the Monomail led it to create a military plane with the same advanced traits. This all-metal, streamlined monoplane, designated the Boeing B-9, could heft 2,400 pounds of bombs and still fly as fast as most fighters of the era. (Photograph by The Boeing Company; reprinted with permission by The Museum of Flight.)

Jim Galvin came to Boeing Field in 1930 and established Galvin Flying Services. He and his company became a fixture in the area for years to come. Galvin was famous for using his aircraft to do almost anything—flying reporters and photographers, conducting search and rescue missions, making supply drops, hauling tourists, and mapping from the air. Galvin operated the first air ambulance in Washington State. Occasionally, Galvin even flew with the bodies of those who had died in western Washington but needed to be transported to another part of the United States for burial. (Galvin Flying Services.)

Jim Galvin, always an enthusiastic aviator, practically lived for flying. His house on Beacon Hill overlooked his prospering aviation business at Boeing Field. He even had a windsock affixed to a pole in his front yard. (Galvin Flying Services.)

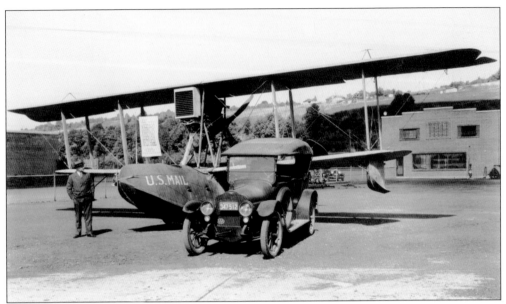

An airplane from the past was brought out for visitors at Boeing Field's open house in September 1933. Boeing's sixth design, the B-1 flying boat, had first graced the skies in 1919. Parked on the field for years after the exhibition, the aircraft was ravaged by weather and vandals until it was rescued by the Seattle Historical Society. Today the restored plane is housed indoors as part of the collection at Seattle's Museum of History and Industry. (Photograph by The Boeing Company; reprinted with permission by The Museum of Flight.)

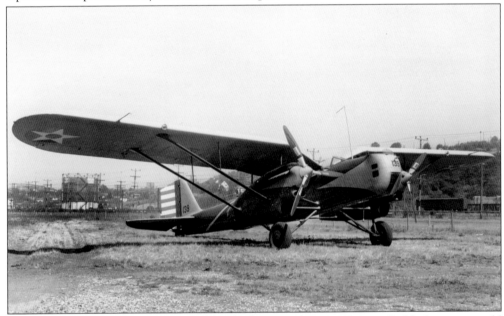

If there was ever a contest for the oddest-looking airplane on Boeing Field, this one would definitely be in the running. Though the Douglas O-35 was a bit hard on the eyes, the four-man army airplane was a fairly revolutionary design in an era of biplanes. The airplane was most likely photographed during the brief time that the U.S. Army flew the U.S. mail in 1934. (The Museum of Flight.)

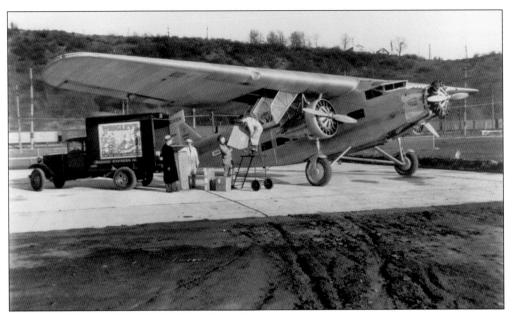

A Ford 5-AT Trimotor from United Air Lines is loaded and readied for a flight to California. The airplane was originally acquired by Pacific Air Transport in 1931 for $58,141. The "Tin Goose," as it was often called, had corrugated-aluminum sheet metal skin on its body and wings. Its thick chord wings allowed its designers to add compartments to hold extra cargo. (The Museum of Flight.)

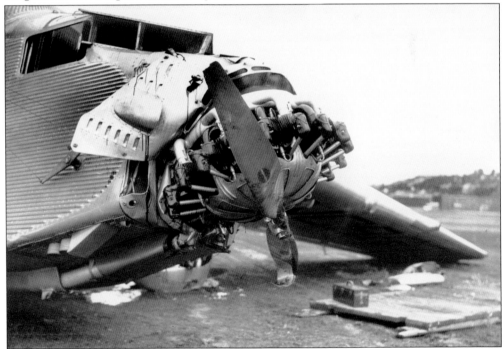

This Ford ran into big trouble at Boeing Field just after takeoff on July 11, 1932. When one of the airplane's engines died just 100 feet off the ground, the pilot was forced to put the trimotor down in what was described as an underdeveloped part of the airfield. The big airplane hit a drainage ditch, smashing its nose, landing gear, and right engine. (The Museum of Flight.)

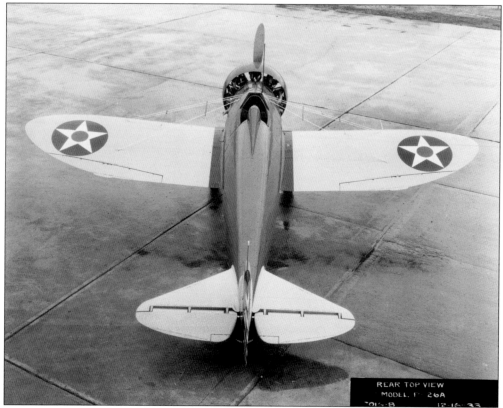

The Boeing P-26 fighter, lovingly called the "Peashooter" by U.S. Army pilots, was a strange mixture of old and new. While the aircraft had roughly the same layout and construction as World War II–era fighters, the fighter's fixed landing gear, exposed support wires, and open cockpit were definitely 1930s-era characteristics. (Photograph by The Boeing Company; reprinted with permission by The Museum of Flight.)

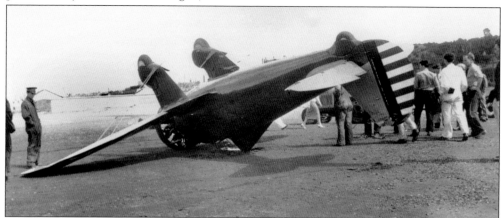

The Peashooter had a tendency to flip over if not handled with care on landings. This P-26 ran into trouble at Boeing Field in 1934. When the short-snouted plane started to turn over, it usually went all the way. After a fatal accident, the airplane's headrest was increased by eight inches and strengthened to protect a pilot's exposed head. (Photograph by The Boeing Company; reprinted with permission by The Museum of Flight.)

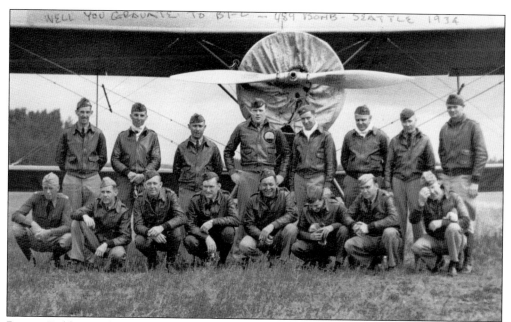

Boeing Field was a hub for more than schools, airlines, and the Boeing Airplane Company in its first years of service. The U.S. Army Air Reserves 489th Bombardment Squadron also called the airport home after moving from Sand Point. Among the flyers seen in this 1934 photograph is Elliott Merrill (lower right). (The Museum of Flight.)

Here a Douglas BT-2C of the 489th Bombardment Squadron takes off from Boeing Field. The open country seen in the background caught the eye of the owner of the photograph, who wrote "Before the Boeing factory" in the margin. Boeing's massive Plant No. 2 was built on the site years after the photograph was taken. (The Museum of Flight.)

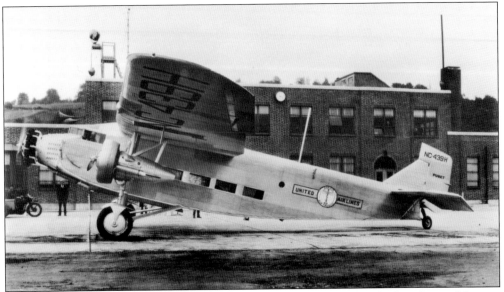

United Air Lines' Ford Trimotor, nicknamed "Puget," was photographed in front of Boeing Field's passenger terminal as its engines were brought to life. The airplane was built in 1931 and was delivered to Pacific Air Transport. When PAT was purchased by United, it became the new owner of the aircraft. Note that the logo appears to have been touched up for public relations purposes. (King County Archives.)

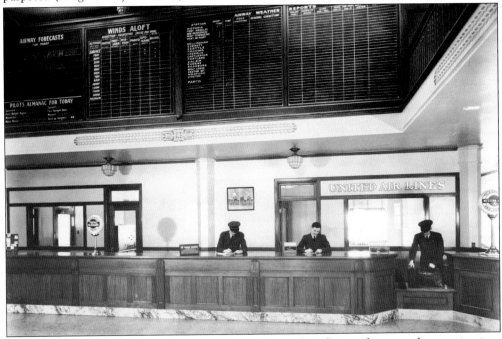

Seattle residents who were traveling by air would begin their flying adventures by stepping into Boeing Field's terminal. Here they would check in with the counter clerk and hand over their baggage (30 pounds maximum). If there was time, they might peruse the weather bureau data chalked on the display boards before strolling to their airplane and winging away to destinations like Pasco, Spokane, or Portland, Oregon. (King County Archives.)

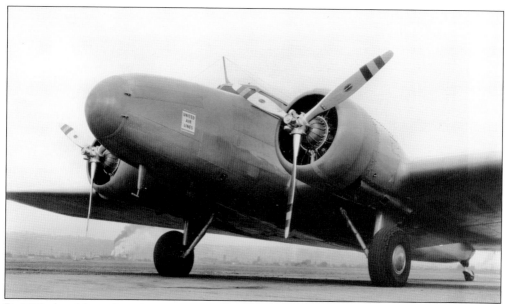

By 1933, the old wooden trimotors were no longer competitive airliner; the Boeing Model 247 was slightly smaller, but it could go faster and was built stronger. Advances made in aircraft design with the Boeing's Monomail and B-9 translated directly into this new, modern twin-engine transport. Because United Air Lines and Boeing were sister companies, UAL received 59 of the first 60 Model 247s built. (Photograph by The Boeing Company; reprinted with permission by The Museum of Flight.)

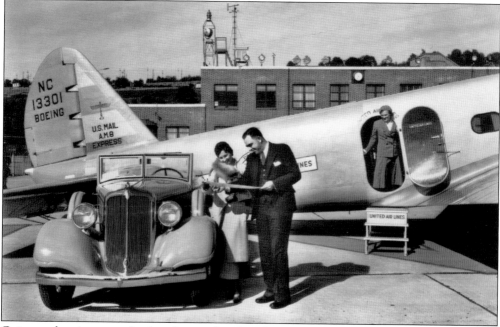

Going to the airport used to be a lot simpler, though it really was not ever like what was pictured here. This staged public relations photograph shows the first Model 247 parked in front of Boeing Field's administration building. (Photograph by The Boeing Company; reprinted with permission by The Museum of Flight.)

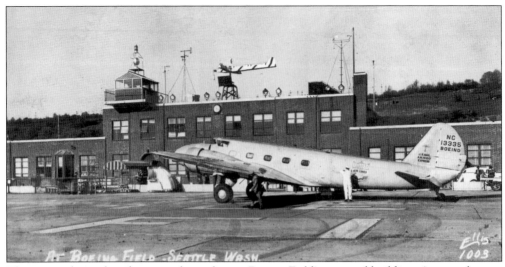

This image shows the advances taking place at Boeing Field's terminal building. A control tower cab and lighting are evident on the roof. A wind-tee can also be seen; it was designed to indicate wind direction. The over 21-foot "whole airplane" was "easily visible in clear weather to aircraft 3,000 feet in the air." At night, the wind-tee was illuminated. (The Museum of Flight.)

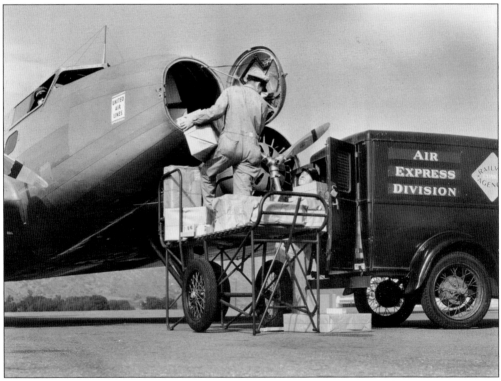

The outdated trimotor designs carried engines in their noses, but in the Model 247, the room was used for extra radio equipment and 400 pounds of mail. Though transporting people was becoming the focus of air transport companies, the original purpose of the flying routes—airmail—was still alive and well in the early 1930s. (Photograph by The Boeing Company; reprinted with permission by The Museum of Flight.)

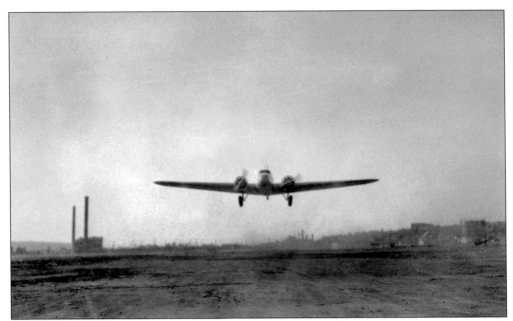

A Boeing Model 247 approaches to touch down on Boeing Field's prepared, but as yet unpaved, runway. Up until World War II, the surface was five inches of crushed rock sub-base covered with another five inches of cinders. Hot oil, consisting of 60 percent alphaltum, was then sprayed on at 60 pounds of pressure. The covering was advertised as "dustless, free from low spots, and more resilient and easier to maintain than concrete." (Robert W. Ellis.)

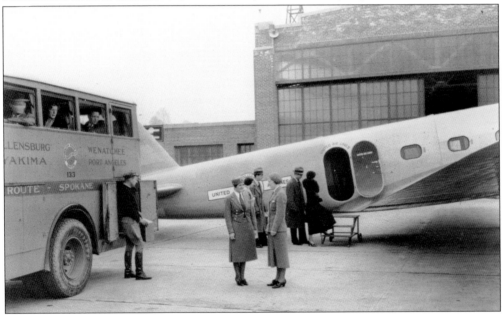

The Model 247 could carry 10 passengers and a crew of three. Here travelers from eastern Washington arrive by shuttle at Boeing Field and are hustled onto the airplane. In the center of the image, a United Air Lines stewardess and bus attendant chat briefly before their respective machines depart in different directions. (Photograph by The Boeing Company; reprinted with permission by The Museum of Flight.)

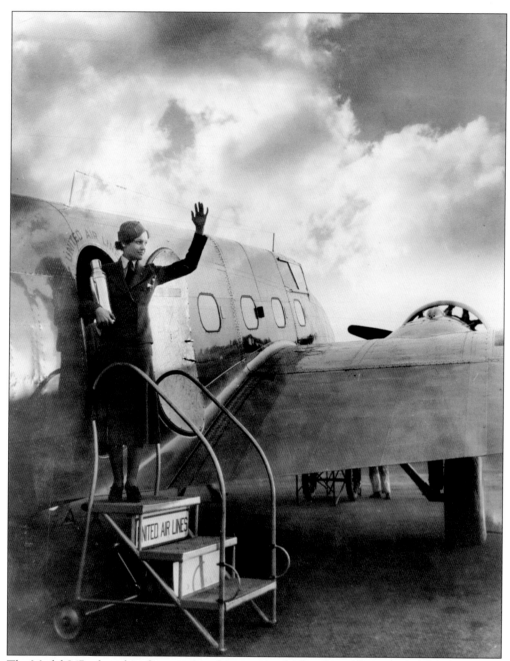

The Model 247 ushered in the age of modern air travel. The idea of flying with stewardesses had caught on and was here to stay. And the clean, all-metal monoplane design became the basis for every airliner developed by Boeing and all other airplane companies. (Photograph by The Boeing Company; reprinted with permission by The Museum of Flight.)

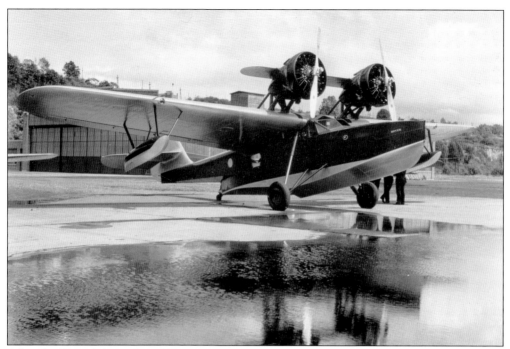

After the United Aircraft and Transport Corporation was split apart by government regulators, William Boeing retired, leaving the company that carried his name. This aircraft, awaiting Boeing's arrival outside the administration building, is his personal transport, a Douglas Dolphin. It is interesting to note that, after the break-up, Boeing chose to use an airplane purchased from a competing aviation company. (Robert W. Ellis.)

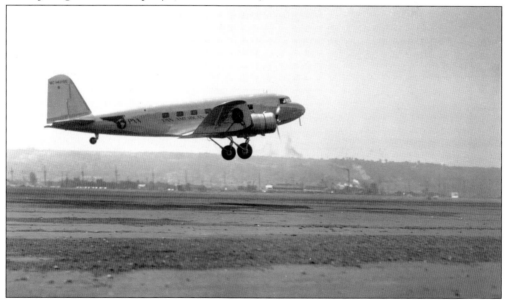

This Pan American Airways Douglas DC-2 carried the bodies of performer Will Rogers and record-setting flyer Wiley Post. They were killed in an air crash near Point Barrow, Alaska, on August 15, 1935. The airplane passed through Boeing Field on its way to Los Angeles on August 19, 1935. (The Museum of Flight.)

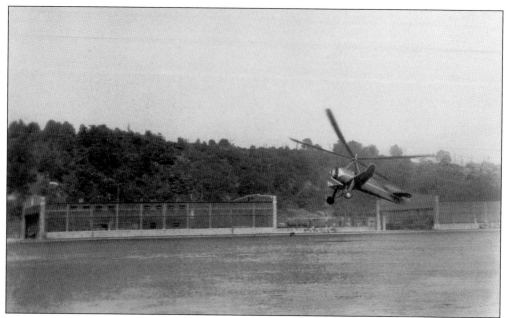

Scores of aircraft have used the runways of Boeing Field over the years. Thousands of helicopters have shuttled in and out too. But not too many of these machines have barnstormed through Seattle. This Pitcairn PCA-2 autogyro was the predecessor to the helicopter. It had un-powered rotor blades and an engine mounted in the nose like an airplane. The strange machine could leap into the air quickly, fly at very slow speeds, and land nearly vertically. (Robert W. Ellis.)

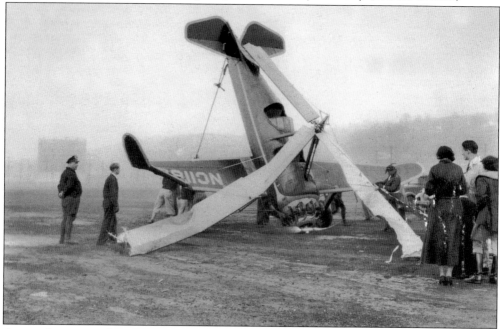

Anyone know a good autogiro repairman? The Pitcairn nosed over on a rough landing, battering its rotors, slicing the vertical tail, and crushing one of its stubby wings. While the pilot fusses over a sagging rotor blade, workmen prepare to haul the tail of the crippled machine back to the ground. (Robert W. Ellis.)

This visiting aircraft parked in front of King County's hangar was on the verge of becoming extinct because of what was happening on the other side of Boeing Field. The Boeing Model 299 design, which would later become the B-17 bomber, made machines like this outdated Martin B-12A too small and too slow for front-line army service. (The Museum of Flight.)

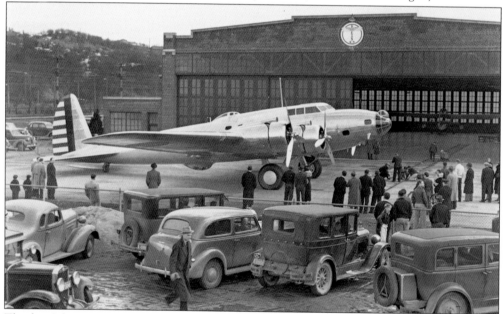

The date July 17, 1935, was a big day for Seattle. On that day, Boeing's Model 299 bomber was rolled out into the sun for its first public appearance. One writer called the new ship an "aerial battle cruiser." A *Seattle Times* reporter called the machine a "flying fortress." This name stuck. When the aircraft was adopted by the U.S. Army in large numbers, it was called the B-17 Flying Fortress. (Photograph by The Boeing Company; reprinted with permission by The Museum of Flight.)

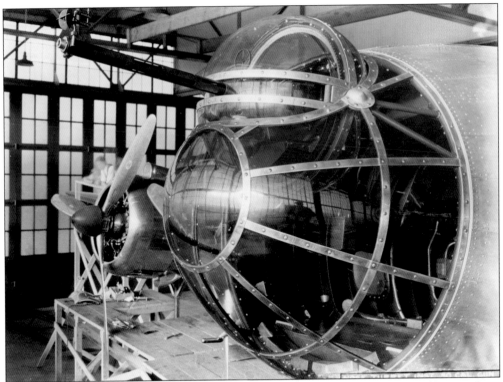

First versions of the B-17 bomber had five stations that could hold .30- or .50-caliber machine guns. The nose dome could be rotated in its entirety, as well as elevated and traversed within its bubble turret. This YB-17 was photographed in November 1936. (Photograph by The Boeing Company; reprinted with permission by The Museum of Flight.)

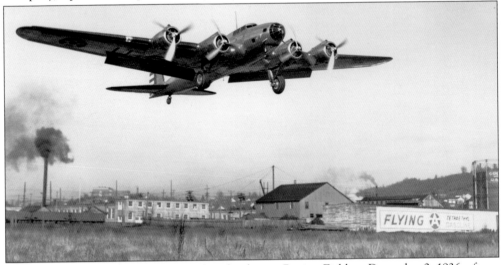

Flaps down, the first Y1B-17 comes in for a landing at Boeing Field on December 2, 1936, after a 50-minute flight around Seattle with an army air corps crew at the controls. Note the supercharger intakes mounted on the tops of the engine nacelles. Later versions of the aircraft had the units relocated under the engines. (Photograph by The Boeing Company; reprinted with permission by The Museum of Flight.)

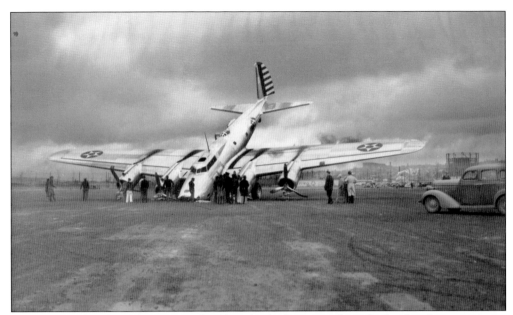

When an army pilot did not properly allow the brakes to cool on the big bomber, it came in for a landing in December 1936 with the disk brakes welded into a solid mass. At touch down, the Y1B-17 went over on its nose with a grinding crunch. Public relations types wanted to get the new airplane out of its embarrassing position before the newsmen arrived at Boeing Field to shoot photographs; however, it was more important to keep the damage to a minimum. In fact, in this image, lead weights are hung around the airplane's propellers to keep the big bomber from flopping back onto its tail too soon. (Photograph by The Boeing Company; reprinted with permission by The Museum of Flight.)

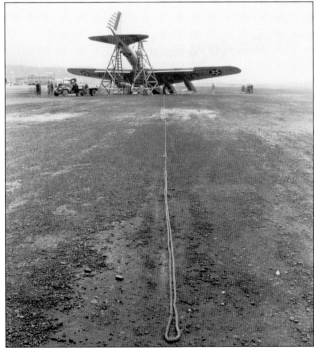

A rope shows the extent of the bomber's skid marks in the crash investigator's photographs. In the background, one can see the double scaffolding trundled together by Boeing Airplane Company workers so they can slowly lower the tail to the ground. (Photograph by The Boeing Company; reprinted with permission by The Museum of Flight.)

Advertising its new, all-metal innovations, the Boeing Airplane Company parked a pair of Peashooter fighters and the revolutionary Model 299 on Boeing Field for a photo shoot in 1936. The airplane on the left, a Model 281, was an export version of the Peashooter. The fighter was being used to check the speed of the big bomber during flight testing. (The Museum of Flight.)

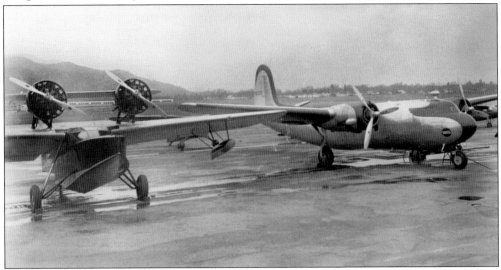

William Boeing's personal pilot, Clayton Scott, took this photograph of Boeing's Douglas Dolphin and his Douglas DC-5 sometime before World War II began for the United States. The latter was the first of only 12 of its type. Boeing named it *Rover*. When war came, the airplane was turned over to the U.S. Navy. While the exact circumstances are unclear, *Rover* apparently was downed by Japanese aircraft near Australia sometime in 1943. (The Museum of Flight.)

In 1936, this South Park truck farmer heard rumors that the Boeing Airplane Company might move to California. Guisseppe Desimone almost single-handedly assured that the growing airplane company would stay in Seattle when he sold Boeing 40 acres adjoining Boeing Field for $1. Boeing built Plant No. 2 on the site. In later years, the civic-minded farmer owned what would become the Pike Place Market. (Museum of History and Industry.)

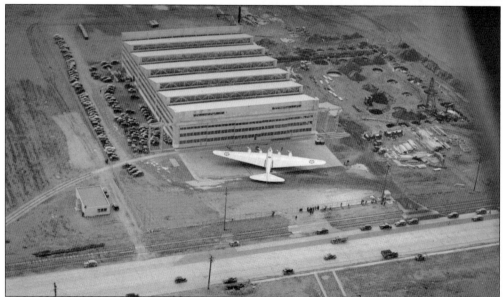

The original Plant No. 2 was touted as monstrous—able to hold nine Model 299 four-engine bombers. Compared to what it would eventually become, it looks fairly small in this photograph, probably taken in 1937. Boeing's XB-15 heavy bomber parked in front had a wingspan of 149 feet. At the time, the airplane was the largest aircraft ever built in the United States. (Photograph by The Boeing Company; reprinted with permission by The Museum of Flight.)

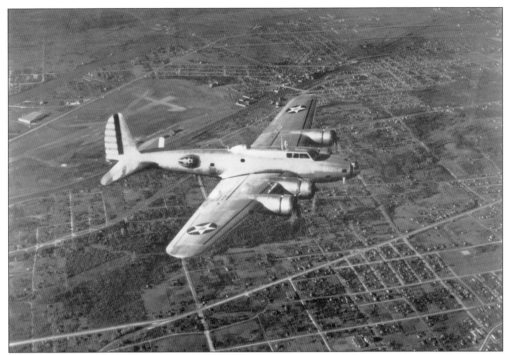

This U.S. Army Air Corps photograph was shot to showcase the Boeing YB-17A, but it also captured large portions of Boeing Field, Georgetown, and Beacon Hill in the background. The steam plant to the north and Boeing's Plant No. 2 are also easily discernible. (Photograph by The Boeing Company; reprinted with permission by The Museum of Flight.)

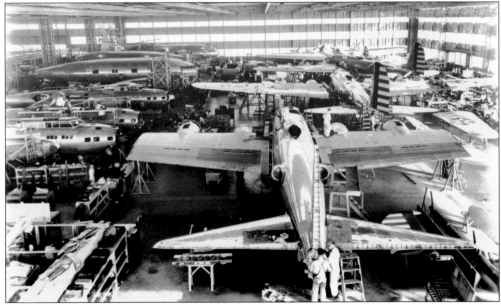

Side-by-side in Plant No. 2, Model 307 passenger planes and B-17 bombers slowly take shape around 1939. While the fuselages were appreciably different, the civilian and military aircraft had much in common, with similar wings, engines, and tail structures. (Photograph by The Boeing Company; reprinted with permission by The Museum of Flight.)

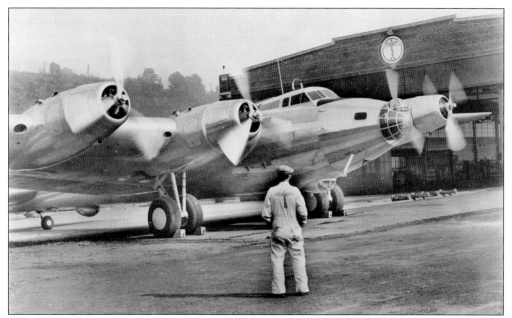

At 19 tons empty, the massive XB-15 was the biggest and heaviest aircraft built in the United States when it first flew on October 15, 1937. The wings were thick enough that a crewman could crawl out in a tunnel and service engine accessory sections while the airplane was in flight. Due to its weight, dual main wheels were used on each main landing gear truck. (Photograph by The Boeing Company; reprinted with permission by The Museum of Flight.)

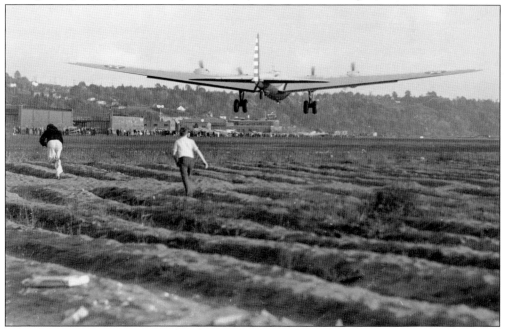

Airport security was a bit more lax during the days before World War II. Here photographers have camped out at the north end of the runway to shoot images of the XB-15 as it rumbles in for a landing. (Photograph by The Boeing Company; reprinted with permission by The Museum of Flight.)

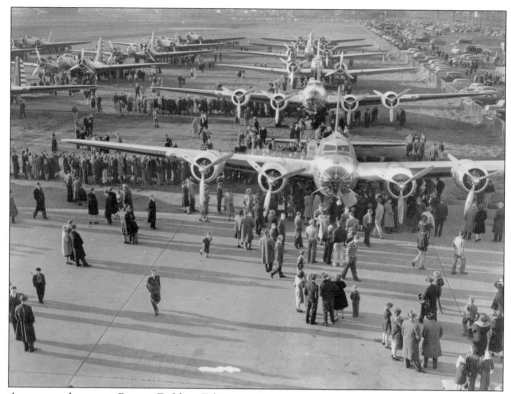

At an open house on Boeing Field on February 16, 1941, Boeing Airplane Company workers and their families get a chance to see some of the latest Army bombers up close. The first two in line are home-grown machines, B-17s. Also seen in the image are smaller Douglas B-18 Bolo and B-23 Dragon twin-engine bombers. (Photograph by The Boeing Company; reprinted with permission by The Museum of Flight.)

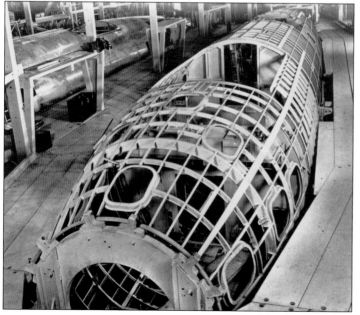

Boeing underwent massive changes in production while it was building Flying Fortress bombers. In the beginning, before the outbreak of World War II, each airplane was almost handcrafted. This B-17C fuselage is a good example. Later thousands of noses, tails, and wings were riveted together in a nearly never-ending line. (Photograph by The Boeing Company; reprinted with permission by The Museum of Flight.)

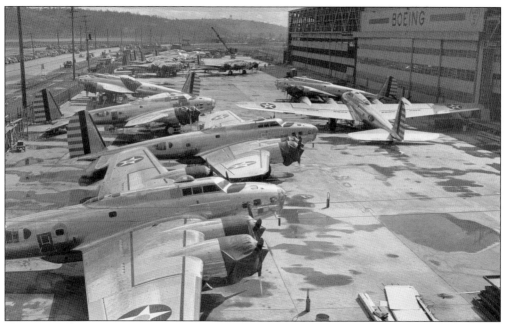

The need for more room on the factory floor is apparent in this photograph. New B-17Cs are parked all over, while a third bay, bigger and taller than the other two, is under construction to the south. (Photograph by The Boeing Company; reprinted with permission by The Museum of Flight.)

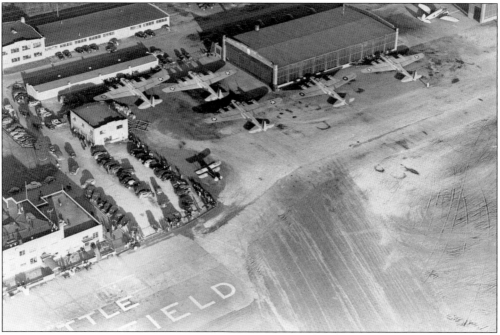

The overload of bombers can be seen across the field too, where Flying Fortresses, in British and U.S. Army markings, stack up outside Boeing's east hangar. At the lower left corner, part of the terminal building can be seen with "Seattle, Boeing Field" painted on the tarmac. At the top right, a Model 247 awaits its next run outside the United Air Lines hangar. (Photograph by The Boeing Company; reprinted with permission by The Museum of Flight.)

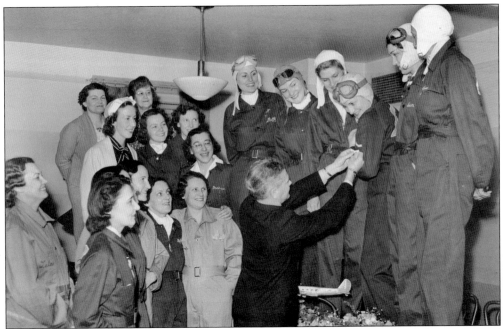

Mildred Merrill (in glasses, center) was one of the five founding members of the Associated Women Pilots of Boeing Field in 1933. The purpose of the organization was to promote interest in aviation and encourage women to become pilots. At this 1938 awards ceremony, six members receive awards as "the gang" proudly looks on. (The Museum of Flight.)

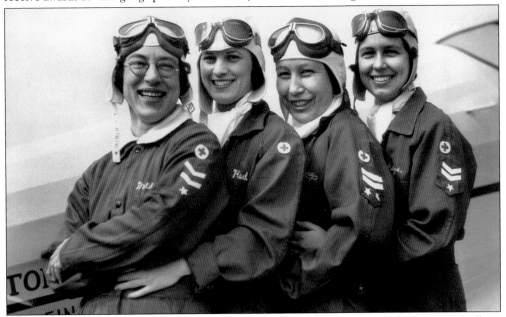

Young Mildred Filz (left) received her first flying lessons from a Boeing Field pilot named Elliott Merrill. They later married. Always looking to take on new aerial jobs, she flew the first airmail from Olympia in 1938 and was one of the founding members of the Flying First Aid Unit, the first group of its type in the Pacific Northwest. The other women in this photograph from left to right are Opal Hiser, Mary Riddle, and Gladys Crooks. (The Museum of Flight.)

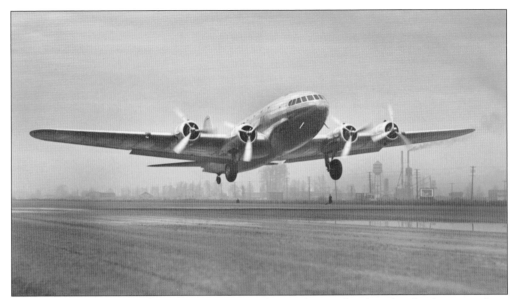

The first Boeing 307 Stratoliner passenger airplane takes to the skies for the first time from Boeing Field on December 31, 1938. The plane could carry 33 passengers and 5 crew members in its fully pressurized fuselage, allowing it to "fly above the weather." Though the airliner was a major step forward, only 10 were built before the outbreak of World War II. (Photograph by The Boeing Company; reprinted with permission by The Museum of Flight.)

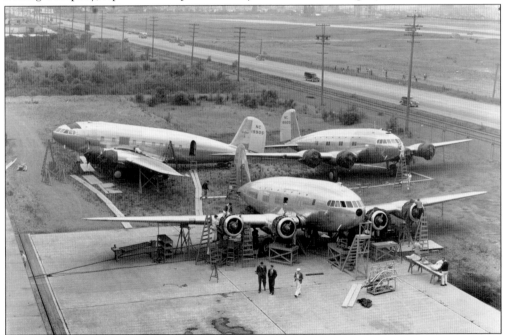

Shot from the roof of Plant No. 2, a trio of 307s undergo finishing touches before their first test flights. They were moved out to make room for other aircraft being constructed inside. Beyond East Marginal Way South, the north side of the airport can be seen, along with the Georgetown steam plant. (Photograph by The Boeing Company; reprinted with permission by The Museum of Flight.)

The Boeing Airplane Company and United Air Lines were part of the same parent company in the early 1930s, so the first new, technologically advanced Boeing Model 247s (left) went to United. The move forced other airlines to look elsewhere for a comparable machine. The Douglas Aircraft Company answered the call with the DC-series—the most successful airliners of the pre–World War II era. Eventually, even United switched to the superior DC-3 aircraft (right) to stay at the top of the passenger transport game. (The Museum of Flight.)

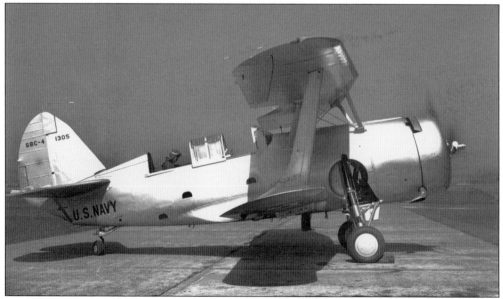

Naval aviators prepare to leave Boeing Field in their Curtiss SBC-4 Helldiver scout bomber. The "Winged Barrel," as the SBC-4 was known, was the last biplane combat aircraft ordered by the U.S. Navy. Some of these planes stayed in service midway through World War II. This particular airframe ended life at an aviation school in Norman, Oklahoma, in 1943. (The Museum of Flight.)

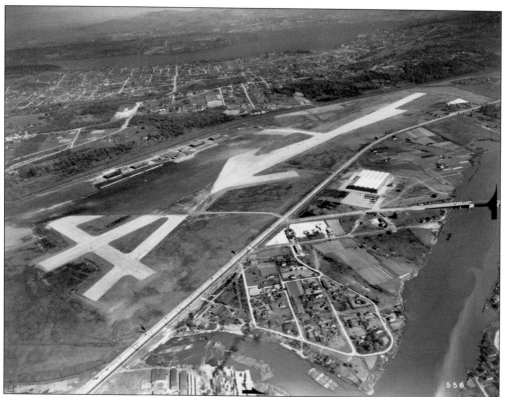

Facing southeast, this April 1938 image shows the layout of Boeing Field's runways, with hangars on the left and Plant No. 2 on the right. Note the portion of the original, wandering Duwamish River jutting out from its now-straightened path. (The Museum of Flight.)

King County expanded its presence on Boeing Field when workers began to build a warehouse in late 1938. By January 1939, it looked like this. The brick building is still there today, converted to offices. The King County Sheriff's Special Operations Center and Emergency Management Program share much of the space in the building. (King County Archives.)

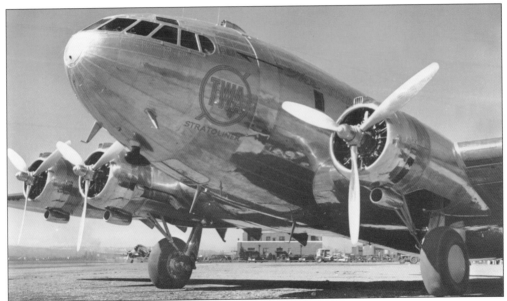

Boeing Airplane Company's biggest customer for the Stratoliner was Transcontinental and Western Air (TWA). The airline purchased five. During World War II, the airplanes flew all over the world, hauling cargo and troops as part of the U.S. Army Air Forces' Air Transport Command. The reinforced area seen on the fuselage was to keep ice from flying off the propellers and denting the airplane's thin skin. (Photograph by The Boeing Company; reprinted with permission by The Museum of Flight.)

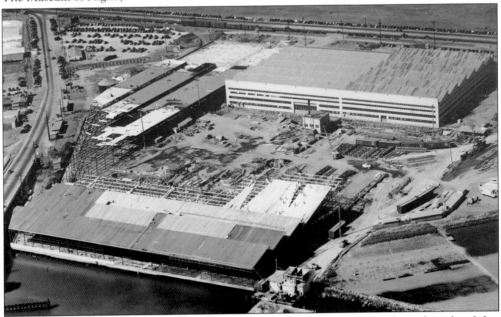

The original Plant No. 2 with the mismatched roofing can be seen at the right side of this photograph as workers expand the building to three times its initial size. The additions and all the new faces at the factory put quite a strain on parking. In this image, automobiles are parked all along East Marginal Way South. (Photograph by The Boeing Company; reprinted with permission by The Museum of Flight.)

Three

WAR YEARS

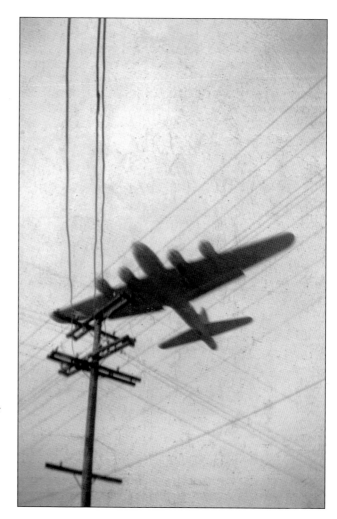

Photographed from the street, a Boeing Flying Fortress coasts "over the fence" into Boeing Field. Especially in the early years, the area surrounding the airfield was an obstacle course of possible trouble in the form of light poles, high tension wires, water towers, and smokestacks. Over time, airport officials worked to eliminate many of the most dangerous hazards. (The Museum of Flight.)

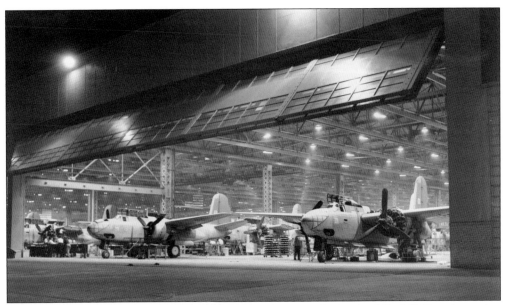

With the doors to Plant No. 2 partly folded upward on a night in the fall of 1941, twin-engine bombers built by the Boeing Airplane Company can be seen undergoing final assembly. The DB-7 bombers were license-built Douglas Aircraft Company machines similar to A-20C Havoc attack bombers. The airplanes, originally intended for France before it fell to Germany, went to England instead. (Photograph by The Boeing Company; reprinted with permission by The Museum of Flight.)

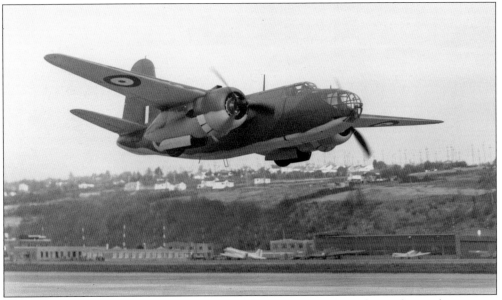

The main wheels of a recently finished Boeing-built DB-7B attack bomber tuck into their engine pods as the airplane takes off over Boeing Field. This one was headed to the Royal Air Force service, while others went to Russia and the United States. The final aircraft was delivered on March 31, 1942. After that, the workers at Boeing Field focused almost exclusively on making four-engine B-17 bombers. (Photograph by The Boeing Company; reprinted with permission by The Museum of Flight.)

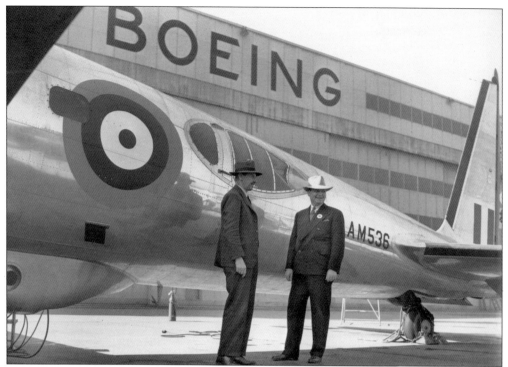

Before America's entry into World War II, many of the Boeing Airplane Company's aircraft were produced for Allied forces. In 1941, Britain's air chief marshal of the Royal Air Force, Sir Hugh Dowding (left), visited Plant No. 2 to inspect bombers. Seen here with Boeing's Claire Egtvedt, the thin, pipe-smoking Scotsman poses in front of a new Fortress I (B-17C). (Photograph by The Boeing Company; reprinted with permission by The Museum of Flight.)

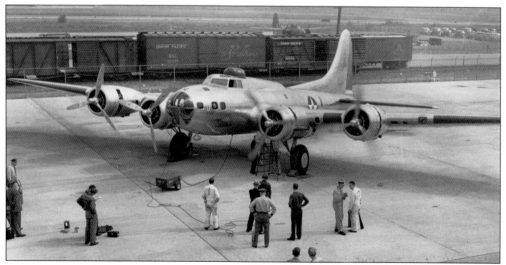

Isn't she a beauty? The engines of the first B-17E Flying Fortress are run up outside the factory. For more stability, the large vertical tail and dorsal spine were added to this model. The bare metal airplane, with its green rudder and top turret, would be tested and then painted all green for delivery. (Photograph by The Boeing Company; reprinted with permission by The Museum of Flight.)

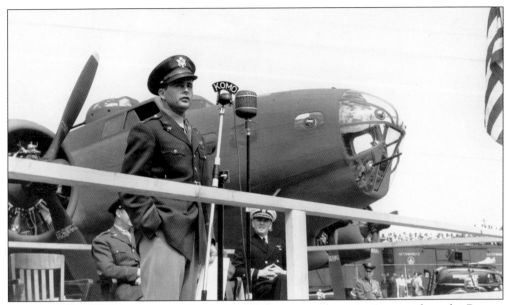

In early 1942, U.S. Army captain Hewitt Wheless came to Plant No. 2 to speak to the Boeing Airplane Company's workers. He said, in part, "I want to thank you for myself and many other pilots who more or less owe their lives to your fine design and workmanship." Wheless's Flying Fortress was ravaged by Japanese fighters during a bombing mission. Amazingly, he and his crew were able to shoot six of their attackers down before returning to base and crash landing. (Photograph by The Boeing Company; reprinted with permission by The Museum of Flight.)

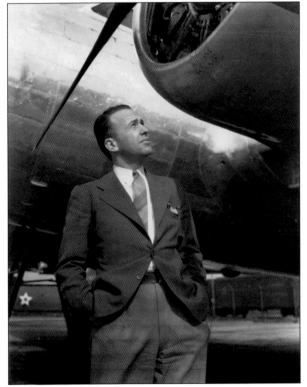

The Flying Fortress was legendary due in no small part to this man, Edward C. Wells. In 1935, at the age of 34, the talented engineer was put in charge of what would become one of the most important bomber projects of World War II. Though he stayed with Boeing until 1972, Wells would always be known as "Mr. B-17." (Photograph by The Boeing Company; reprinted with permission by The Museum of Flight.)

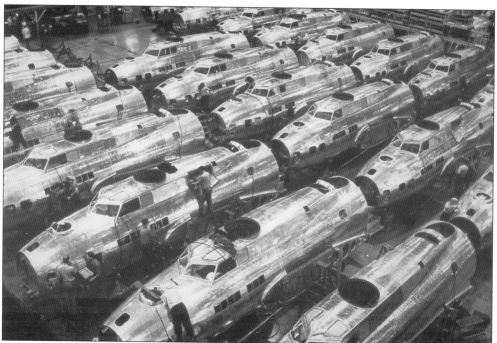

Wall-to-wall in Plant No. 2, forward fuselages of the Flying Fortress bombers are assembled. The major components were built up separately then joined together at production breaks. While the technique had significant advantages in the shop, it also was helpful with combat repairs in the field where an entire new tail or outboard wing might be spliced onto a heavily damaged airplane to keep it flying. (Photograph by The Boeing Company; reprinted with permission by The Museum of Flight.)

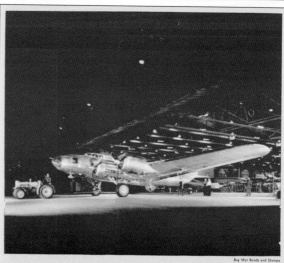

Buy War Bonds and Stamps

Another Fortress Is Hatched

A mammoth door is raised. Without fanfare, another Boeing Fortress is rolled out — ready to fly!

Looming huge and mysterious in the half-twilight, the Fortress beneath its trim, classic lines sheathes interior structures and installations that are both durable and complex.

Despite the many difficulties entailed in building so complicated a weapon, Boeing is able to hatch out Flying Fortresses* in constantly accelerating volume, because it has reduced even the most involved procedures to simple,

accurate operations which can be learned quickly. This means manufacturing planning of the highest order.

Each part, each function, each assembly (and they total thousands) had to be arranged and tooled. Boeing, for example, developed more than 100,000 special tools to do the job.

One result is that Boeing's output is the greatest of any aircraft manufacturer — per man, per machine, per unit of floor space. Today, Boeing is building Flying Fortresses at a rate eight times greater than the month before Pearl Harbor.

Further, the results of Boeing's planning are, in turn, helping other companies to speed up America's aircraft production. For, under the BDV agreement, Boeing has made its plans and specifications available to both Douglas and Vega which also build Boeing Flying Fortresses.

Once peace is won, you can look to Boeing's research, design, engineering and manufacturing genius to bring you many a new and interesting product . . . with the sure knowledge that if it's "Built by Boeing" it's bound to be good.

DESIGNERS OF THE FLYING FORTRESS · THE STRATOLINER · PAN AMERICAN CLIPPERS **BOEING**

THE TERMS "FLYING FORTRESS" AND "STRATOLINER" ARE REGISTERED BOEING TRADE-MARKS

With a little bit of over-the-top drama, this 1943 advertisement describes the multitude of B-17s being born at Plant No. 2 on the edge of Boeing Field. The machine in the photograph is a B-17F-model, similar to the most famous Flying Fortress, the *Memphis Belle*. (The Museum of Flight.)

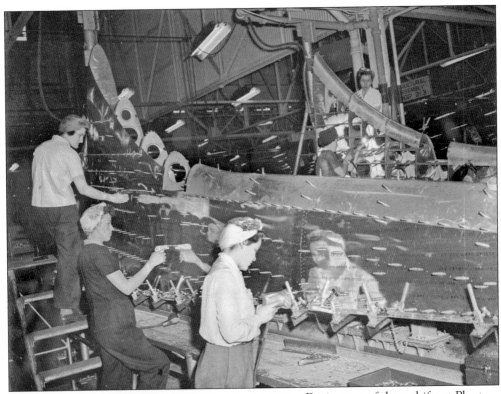

During one of three shifts at Plant No. 2, women workers mill around the virtually never-ending parade of aircraft parts. Here jigs hold the distinctively shaped tails of big Flying Fortress bombers as the Rosies affix the silver Alclad skin to the ribs and stringers. (King County Archives.)

Safety and fashion did not always go together in the factory. Women workers, often called "Rosie the Riveters," were encouraged to wear clunky safety glasses and keep their hair covered because it could get caught in machinery. The lapel patches show the workers' departments: clerical, design, or, in this case, production. (Photograph by The Boeing Company; reprinted with permission by The Museum of Flight.)

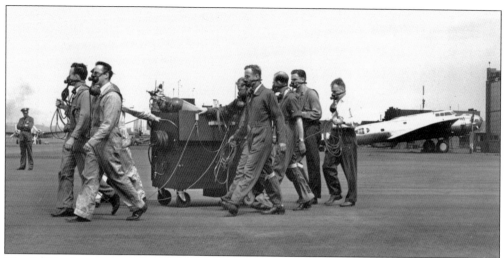

The B-17 had engines equipped with superchargers, allowing the bomber to fly to great heights. Just how high was classified at the time, but it was "over 35,000 feet." At that altitude, humans could not survive without oxygen. The Boeing Airplane Company led the way in pioneering new systems and procedures in aircrew survival at great heights. These men are on their way from the altitude chamber to a stratospheric flight in a B-17. They had to keep their masks on while on the ground to keep from reintroducing nitrogen to their bloodstreams. (Photograph by The Boeing Company; reprinted with permission by The Museum of Flight.)

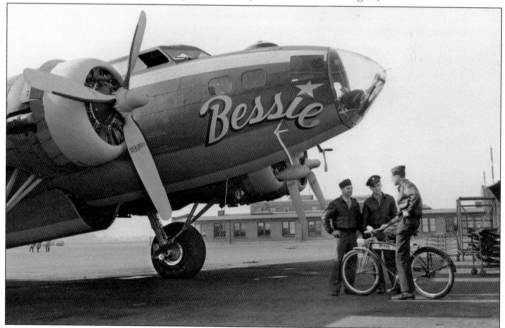

Bessie was a Seattle-built B-17F that came home early. Starting in 1943, the orange-striped Flying Fortress became a demonstrator plane, making the rounds to bomber instruction bases throughout the United States and teaching students and instructors the newest information on heavy bomber operations and equipment. The bicycle, *Little Bessie*, went along on the tour too. It was used as transportation for crewmen at each new airfield. (Photograph by The Boeing Company; reprinted with permission by The Museum of Flight.)

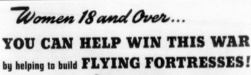

YOU CAN HELP WIN THIS WAR
by helping to build FLYING FORTRESSES!

$140* Monthly WHILE LEARNING! $175* Minimum Monthly After Six Months! A Variety of Jobs Ideally Suited to Women! Apply Now—"Keep 'em Flying"

*Based on 48-hour work-week now in effect in almost all departments within the factory

CERTAINLY, you want to "pitch in" and do your part to back up the men in uniform. Here's how you can start right now—and earn good money—even though you've never worked before!

Boeing particularly needs women 18 to 40 for active work in building one of Uncle Sam's greatest weapons for victory—the Boeing Flying Fortress! Already, 40% of the employees in our clean, well-lighted, modern plant are women. But we need hundreds more to "Keep 'em Flying" all over the world!

APPLY FOR INFORMATION TODAY

If you're 18 or over, in good physical condition, and a U.S. citizen, apply for complete information and a courteous, friendly interview—at the Boeing uptown office. Second and Union. Office hours: Monday, 7:30 A. M. to 8:30 P. M.; other weekdays including Saturday, 7:30 A. M. to 5:30 P. M.

THESE BOEING WOMEN ARE HELPING TO BLAST THE AXIS

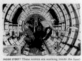

During World War II, the Boeing Airplane Company actively recruited all types of people to work at Boeing Field. Women were encouraged to work at the factory while their sons, husbands, and fathers were fighting overseas. For a time, almost half of the workers putting a card in Boeing's punch clock each morning were female. (The Museum of Flight.)

There was a time when everyone at Plant No. 2 worked practically elbow-to-elbow. But the airplane factory continued to grow and, for efficiency's sake, a multitude of small vehicles were required to haul equipment and people over the expansive campus. There were "bantam" scooters, "truckettes," forklifts, and "H and H" trucks. The machines at the front of this vehicle vanguard were both indoor and outdoor versions of machines called "Clarkarts." They were powered by four-cylinder engines. (Photograph by The Boeing Company; reprinted with permission by The Museum of Flight.)

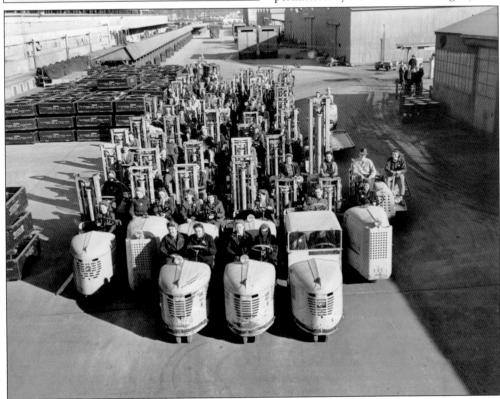

Gasoline was rationed during wartime. But, at the same time, thousands of workers were required at Boeing Field every day to make aircraft. The company resorted to one of the first large-scale carpooling and transit service in the region. This bus is bringing people from the Vashon and Port Orchard ferry, arriving at the Fauntleroy landing in west Seattle. (Photograph by The Boeing Company; reprinted with permission by The Museum of Flight.)

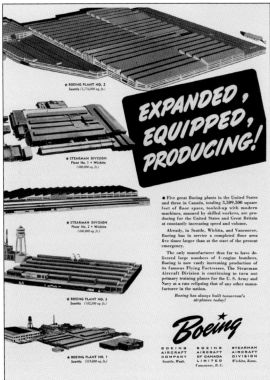

This 1941 advertisement shows the Boeing Airplane Company's factories in the United States. Plant No. 1, the original Boeing building, located north of Boeing Field on the Duwamish River. Plant No. 3 was the former Fisher Body Company building on East Marginal Way South near the south end of Boeing Field. This 16-acre leased facility was used primarily for sub-assembly work. (The Museum of Flight.)

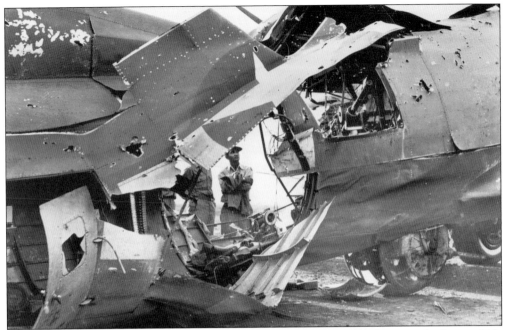

U.S. Army flyers found, time and again, that Boeing's Flying Fortress bombers were built incredibly tough. This B-17 returned to a base in Italy after receiving a direct blast from an anti-aircraft shell over Hungary in 1944. It was reported that the bomber, dubbed *Sweet Pea*, came home held together by "a few longitudinals and 27 inches of skin." (National Archives/U.S. Army.)

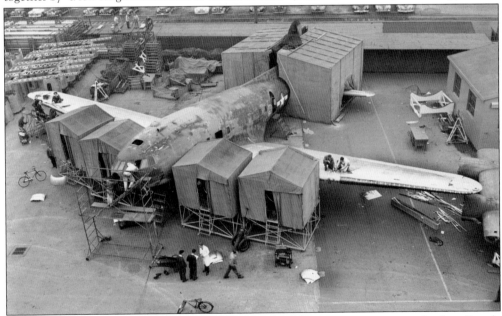

Boeing 307 Stratoliners, appropriated by the U.S. Army for transport use, came back to Seattle "with their tongues hanging out" in late 1944. Five planes were to be refitted by the Boeing Airplane Company before their return to civilian passenger service with TWA. They received massive overhauls outside Plant No. 2, including new wings, tails, landing gear, and electrical systems. (Photograph by The Boeing Company; reprinted with permission by The Museum of Flight.)

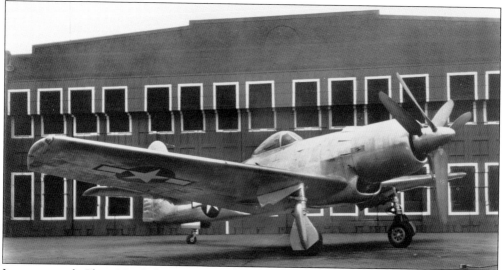

It was not only Plant No. 2 that was camouflaged during World War II. The Boeing Airplane Company's hangar on the opposite side of the field was made to look like an office building with windows painted along the brick and hangar doors. Boeing's impressively large, single-man XF8B-1 navy fighter prototype sits out in front of the disguised hangar in 1944. (Photograph by The Boeing Company; reprinted with permission by The Museum of Flight.)

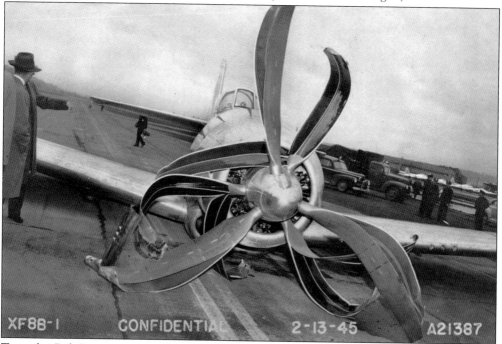

Test pilot Bob Lamson was at the controls of the XF8B-1 navy fighter during high-speed taxi tests at Boeing Field when the airplane became airborne—just for a second. With the weight off the gear, it began to retract automatically, with the big plane settling back onto the runway. The engine blew apart as the propellers beat themselves to pieces on the pavement. Lamson was unhurt in the crash. (Photograph by The Boeing Company; reprinted with permission by The Museum of Flight.)

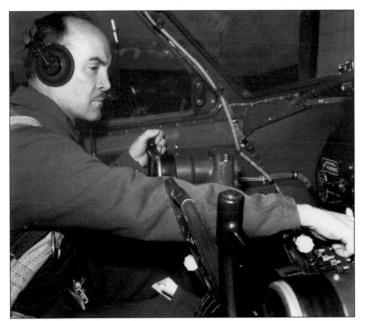

Eddie Allen was the antithesis of the stereotypical swashbuckling Hollywood test pilot. He liked yoga, Egyptology, and poetry. He was also an exceptional flyer. Even when employed by the Boeing, the company loaned him out to other organizations to reign in their most troublesome creations. *Time* magazine stated that "His hand at the controls cut insurance rates in half." (Photograph by The Boeing Company; reprinted with permission by The Museum of Flight.)

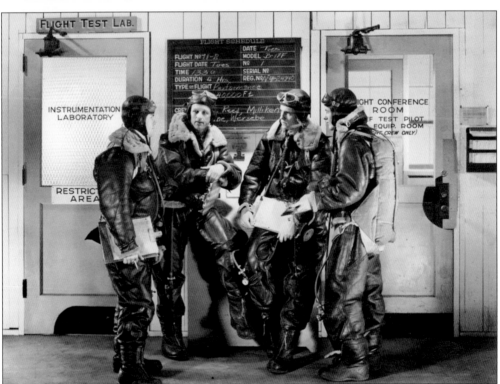

Flyers dressed for the extreme cold at 40,000 feet discuss last minute preparations outside the Boeing Airplane Company's flight test lab before taking a B-17F Flying Fortress up for a high-altitude run. Two of these men, Charles Blaine and Edward Wersebe, were later killed when they jumped from the burning XB-29 bomber during a flight test in February 1943. (Photograph by The Boeing Company; reprinted with permission by The Museum of Flight.)

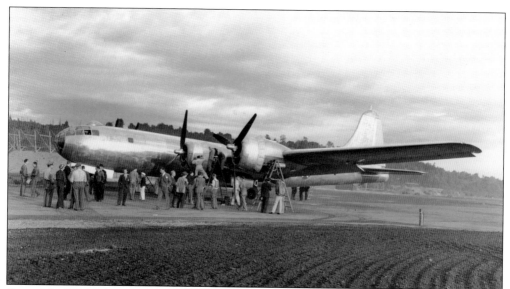

One of the XB-29s has just returned from another trouble-filled test flight, barely making it back to Boeing Field. The fires and mechanical difficulties that plagued the new aircraft may have left it grounded if it had not been wartime and badly needed for fighting in the Pacific. (Photograph by The Boeing Company; reprinted with permission by The Museum of Flight.)

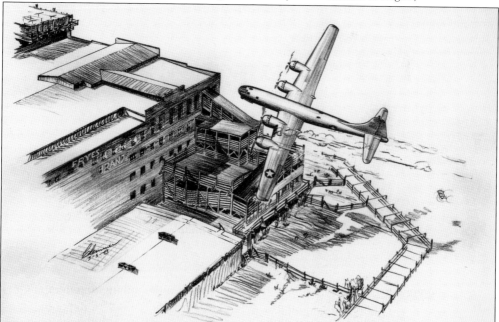

A Boeing artist later recreated the scene a split second before the Superfortress plunged into the side of the Frye & Company meatpacking plant on Airport Way. With landing gear down and its left wing canted toward the ground, the airplane hit the building, exploded, and burned. The huge fire was fueled by aviation gasoline in addition to lard and fat from the meatpacking stores. Firefighters told the press at the nightmarish scene that the fire was extremely difficult to bring under control. (Photograph by The Boeing Company; reprinted with permission by The Museum of Flight.)

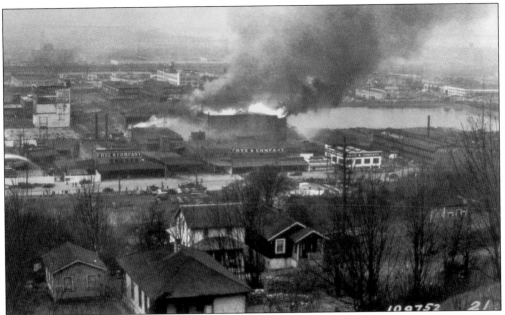

Seen from Beacon Hill, the Frye & Company plant and Boeing's top secret bomber go up in flames on February 18, 1943. Some speculated that Eddie Allen was attempting to set the stricken XB-29 down in the open, water-covered area north of the building. The accident was called the worst fire since Seattle's Great Fire of 1889, claiming the lives of 11 flyers, 20 plant workers, and a fireman. (National Archives/U.S. Army.)

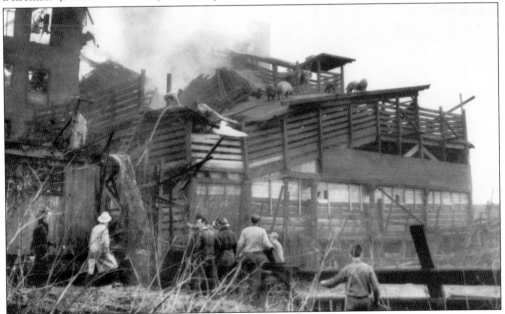

The first rescuers arrive on the scene, nearing the hole in the brick facade made by the bomber. Note the pigs loose on the roof of the cattle chute above their heads. Only a tiny portion of the tail of the Superfortress can be seen at the corner of the chute. In newspaper articles that showed this photograph, even that small fragment of the top secret bomber was censored out of the image. (Photograph by The Boeing Company; reprinted with permission by The Museum of Flight.)

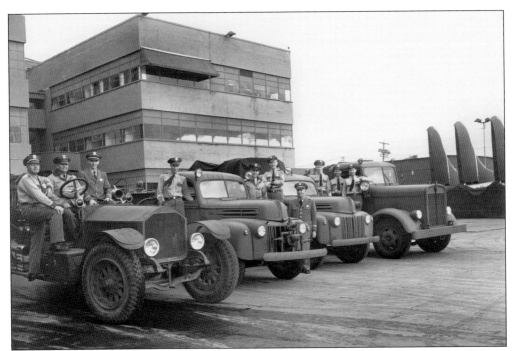

The Boeing Airplane Company's fire crews pose for a photograph with their trucks at Boeing Field. The fleet included a number of Seattle-built Kenworth pumpers. The Kenworth Motor Truck Corporation also made B-17 sub-assemblies and heavy duty wreckers for the army. During World War II, Boeing's fire trucks went from bright red to the same olive drab schemes seen on the warplanes. (Photograph by The Boeing Company; reprinted with permission by The Museum of Flight.)

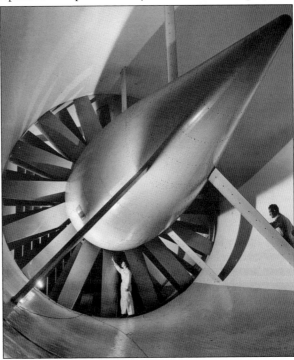

Boeing's new wind tunnel, part of the Plant No. 2 complex, was dedicated to the late Eddie Allen. It was considered one of the most advanced experimental centers in the United States. The 16 laminated spruce blades generated wind speeds up to 700 miles per hour. The streamlined cone helped smooth the air passing the fan's hub. (Photograph by The Boeing Company; reprinted with permission by The Museum of Flight.)

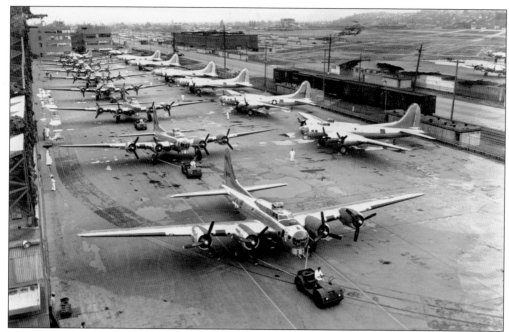

Not a bad output for one day's work. At the height of production, the men and women working in Plant No. 2 made 16 four-engine Flying Fortresses every day. Nearly every hour, day and night, the big doors were opened and another B-17 was rolled onto the perimeter of Boeing Field. (Photograph by The Boeing Company; reprinted with permission by The Museum of Flight.)

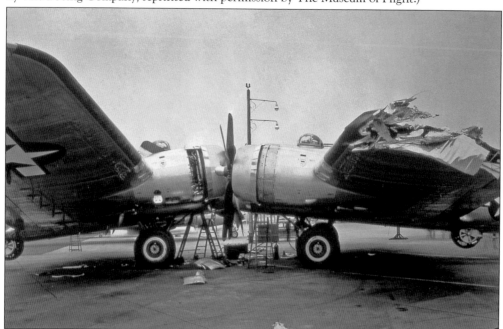

Careless aircraft handling left two beautiful new B-17Gs severely damaged outside Plant No. 2. One taxiing aircraft crashed into a parked bomber, leaving the pair smashed together. With the frantic pace of wartime production, the airplanes were probably moved aside and repaired as time allowed or perhaps simply robbed of useful parts. (The Museum of Flight.)

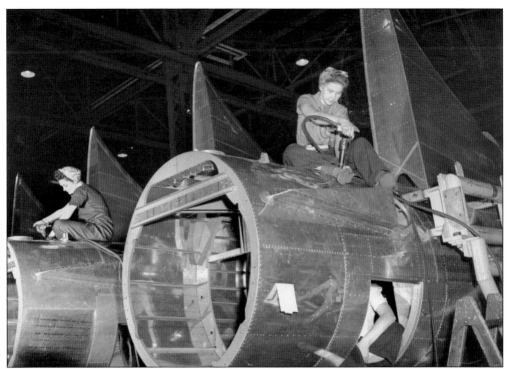

Factory work was often dirty, boring, and a bit dangerous. Here women pound rivets into the tail section of a Flying Fortress. Inside the fuselage, the worker's partner holds a heavy bucking bar up to smash the rivet once it is hammered through. (Photograph by The Boeing Company; reprinted with permission by The Museum of Flight.)

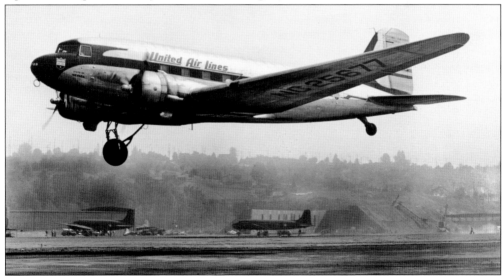

Photographed in 1945, a United Air Lines Douglas DC-3 takes off from Boeing Field. Note the lazy starboard main wheel, slow to retract. The airplane was acquired by United in 1940 and served with the airline until 1959. After it was released by United, the airplane passed from owner to owner until, in the 1970s, it was involved in a nose-over accident in California. The careless flyers were discovered to be using the old airliner to transport marijuana. (The Museum of Flight.)

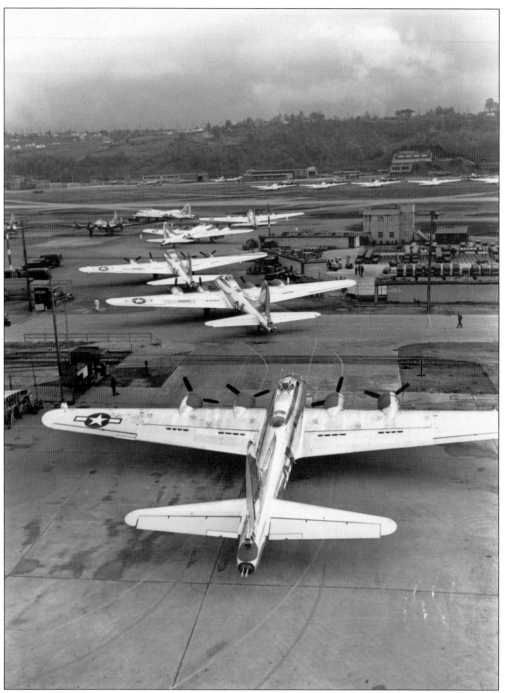

Like the airfield, East Marginal Way South was closed to the public as the wartime push to make as many bombers as possible was underway. Besides the lines of beautiful new B-17Gs, one can spot a few DC-3s on the other side of the runway. Also a new, camouflaged B-29 Superfortress can be seen between the southernmost hangar and the revetment. (Photograph by The Boeing Company; reprinted with permission by The Museum of Flight.)

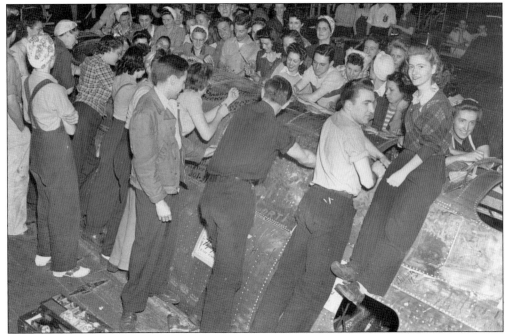

Boeing workers happily pause during their shift to paint their names on the 5,000th Seattle-built B-17 Flying Fortress to be produced since Pearl Harbor. The brightly colored signatures covered every part of the airplane. *Boeing News* stated that it was "undoubtedly the dirtiest warplane ever accepted by the U.S. Army." (Photograph by The Boeing Company; reprinted with permission by The Museum of Flight.)

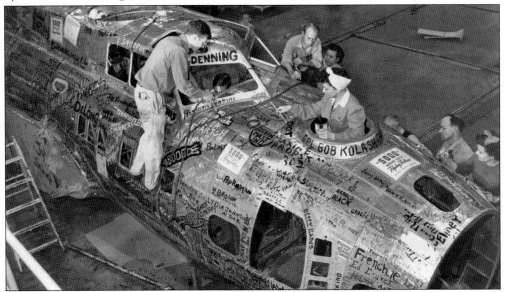

Names continue to be applied as the 5,000th B-17 as it moves down the line in Plant No. 2, gathering rivets and more components. "The endorsing of the *Five Grand* did not start out as a publicity stunt," stated the Boeing Airplane Company. "It began spontaneously and gained momentum like a prairie fire." (Photograph by The Boeing Company; reprinted with permission by The Museum of Flight.)

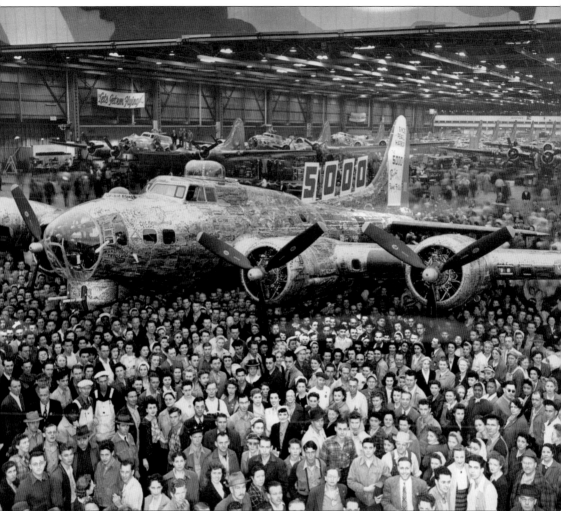

The *Five Grand* was rolled from the factory on May 12, 1944. In this photograph, a fraction of those who built the bomber on Seattle's Boeing Field pose with their newest creation. The B-17 was assigned to a bomber group in Europe and survived the war after flying 78 missions. Sadly, plans to save the airplane for the city of Seattle fell through, and after the war; the historic bomber was scrapped in Arizona. (Photograph by The Boeing Company; reprinted with permission by The Museum of Flight.)

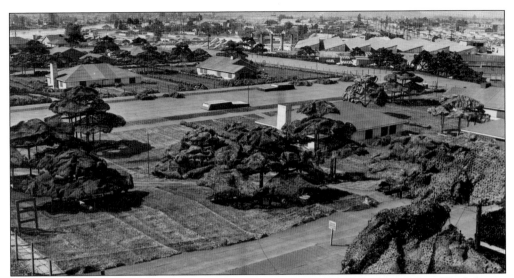

An elaborate web of mock roads, lawns, trees, houses, and cars hid the top of Plant No. 2 during World War II. The faux community was made from chicken feathers and spun glass. But the "harmless Seattle suburb" cleverly hid one of the country's most important airplane factories—a facility that was making heavy bombers that were critical to the war effort. (Photograph by The Boeing Company; reprinted with permission by The Museum of Flight.)

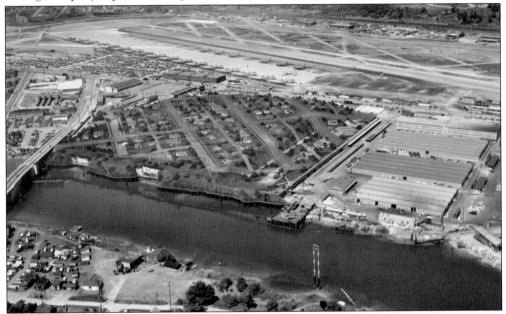

Shot right after World War II, this aerial image of Plant No. 2 in disguise gives one an idea of how the camouflage was applied to the giant building. The artificial neighborhood even had its own natural-looking shoreline where the factory met the Duwamish River. Though the camouflage was quite elaborate, some skeptics say the disguise would not have fooled a trained Japanese bomber crew. However, enemy flyers arriving at high altitude in the dark or in Seattle's commonly cloudy skies might have been briefly confused by the scene, spreading their bombs among the more attractive-looking targets surrounding the field. (Photograph by The Boeing Company; reprinted with permission by The Museum of Flight.)

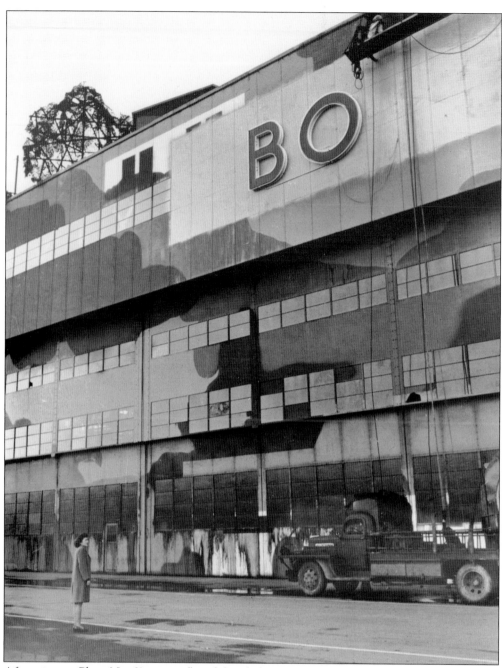

After victory, Plant No. 2's camouflaged facade begins to get a makeover back to its pre-war, civilian colors. The big neon-lit letters, spelling out the company's name, were taken down while the nation was at war. Here they are being re-hung, soon to be seen again by those driving down East Marginal Way South and the civilian pilots once again flying at Boeing Field. (Photograph by The Boeing Company; reprinted with permission by The Museum of Flight.)

Four

JET CITY

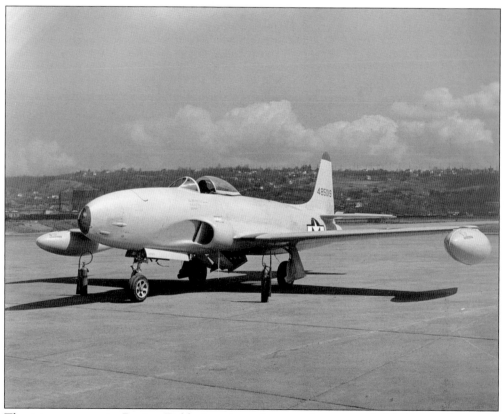

The jet age comes to Boeing Field. A curious photographer snapped this image of one of a group of Lockheed P-80 jet fighters visiting the field in 1946. This particular Shooting Star was modified to become a reconnaissance aircraft and flown in the 1946 Cleveland Air Races' speed dash. Lt. William Reilly was clocked at a top speed of 578.36 miles per hour in this plane. (The Museum of Flight.)

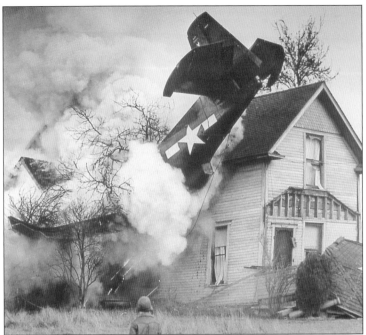

Such are the dangers of living near an airfield. In 1946, a navy Grumman Avenger torpedo bomber lost power on takeoff from Boeing Field and ended up lodged into a house on Cloverdale Street in the South Park neighborhood west of the airport. The airplane's wing hit a pole, and the stricken aircraft plunged into the dwelling and started to burn. Amazingly, the pilot made it out of the crash unhurt. (National Archives/U.S. Navy.)

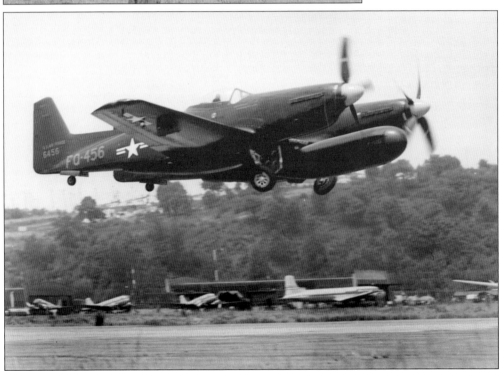

Another unusual aircraft to visit Boeing Field was this North American F-82F Twin Mustang. Conceived near the end of World War II as a two-man fighter, the airplane allowed a pair of pilots to share flying duties on long missions. This one was equipped for a night fighter role with glossy black paint and a large radar pod under the center wing section. In this case, the right cockpit, often used by the radar operator, appears to be empty. (The Museum of Flight.)

Seemingly parked in the wrong decade, an Empire Air Lines Model 247D (right) shares the ramp with a C-97 Stratofreighter in 1946. The vintage airplane was one of a handful of the type purchased by the Lewiston, Idaho-based airline and overhauled by the Boeing Airplane Company. Empire's president told reporters that the "excellent ships" were perfect for routes in Washington, Oregon, and Idaho. (Photograph by The Boeing Company; reprinted with permission by The Museum of Flight.)

Passenger service came back to Boeing Field after World War II but only briefly. Here a United Air Lines Douglas DC-6 comes in for landing. Soon, however, most passenger flights and airlines were moved to the Seattle Tacoma International Airport (Sea-Tac), which opened to scheduled flights in 1947. (The Museum of Flight.)

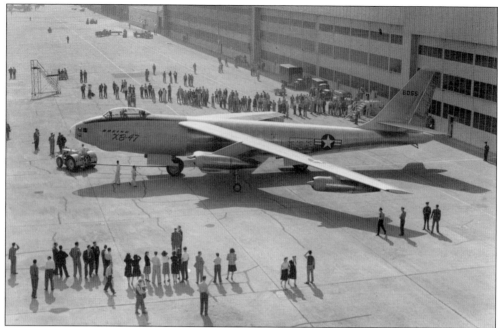

In 1947, America's newest, most radical bomber, the Boeing XB-47, was towed out of Plant No. 2 and into the sunlight. *Boeing News* magazine stated, "Spectators jammed the factory apron, traffic stopped on the highway beyond as onlookers viewed the big Stratojet with awe." (Photograph by The Boeing Company; reprinted with permission by The Museum of Flight.)

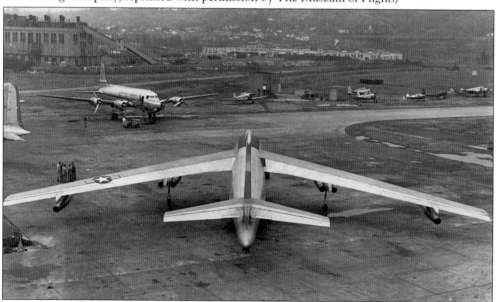

The swept wings of the B-47 Stratojet were copied from German studies of high speed jet aircraft captured by the Allies at the end of World War II. Actually, the design process had been started, then halted, and significantly modified once the new information came to light. The Boeing Airplane Company shared its newly gained knowledge with the rest of the American aviation community, and, even today, most jet aircraft owe their basic form to the sleek Stratojet design. (Photograph by The Boeing Company; reprinted with permission by The Museum of Flight.)

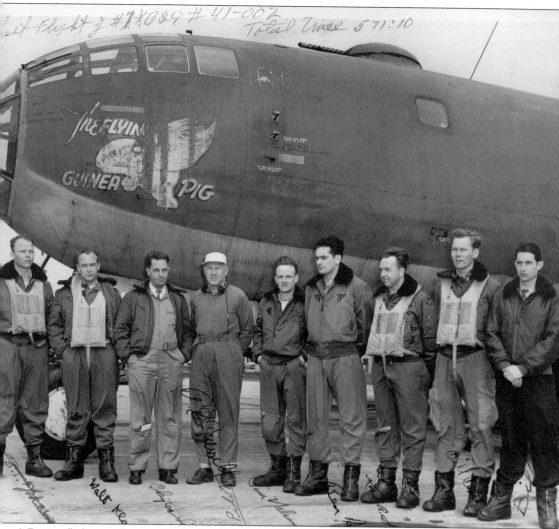

A Boeing flight crew lines up for the last flight of an old friend in 1947. The old XB-29 Superfortress, ordered in 1941 and first flown in 1943, was being retired. Known as *The Flying Guinea Pig*, the airplane had more than 500 hours of testing time in the air. Two of the crew, Clayton Scott (third from left), and Elliott Merrill (fourth from left), were thought to be two of the first pilots to ever land at Boeing Field. (Photograph by The Boeing Company; reprinted with permission by The Museum of Flight.)

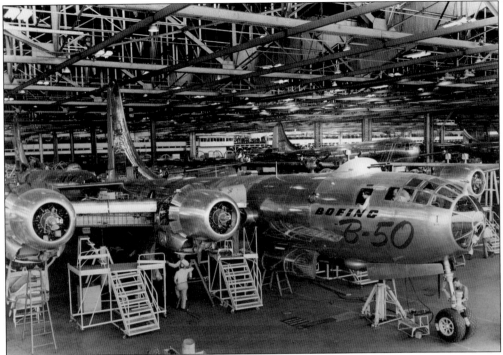

The expansive Plant No. 2 was used to construct new designs after World War II. Here a pair of offshoots from the B-29 bomber can be seen on the factory floor. The B-50, in the foreground, was an updated bomber with a new tail and bigger engines. Beyond, a Boeing C-97 can be seen. With wings and tail similar to the B-29, the new airplane had a "double bubble fuselage" capable of holding troops, cargo, or passengers. A civilian version of the C-97 was dubbed the 377 Stratocruiser. (Photograph by The Boeing Company; reprinted with permission by The Museum of Flight.)

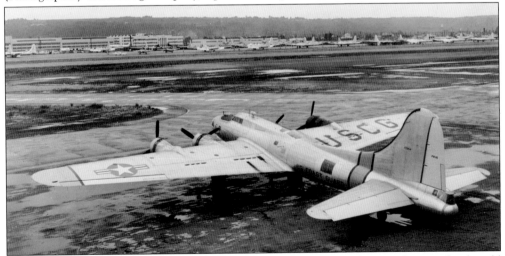

After most had gone to the scrap pile (or would be soon), a curious photographer caught this old Boeing B-17 parked on the field. Used by the U.S. Coast Guard for search and rescue work, the airplanes were re-designated PB-1Gs. About 180 of the ex-bombers were stripped of armament by military outfits and equipped with lifeboats under their bellies. (Photograph by The Boeing Company; reprinted with permission by The Museum of Flight.)

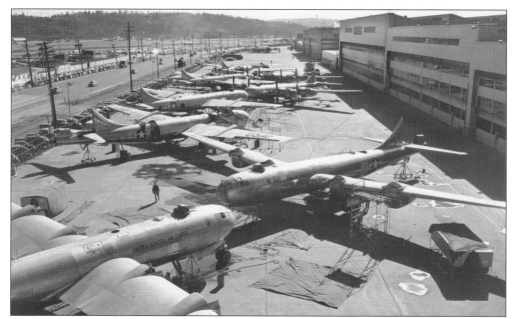

Again, Boeing's tarmac in front of Plant No. 2 is filled with airplanes as the company works to fulfill orders for the U.S. Air Force. Here Boeing B-50s await engines. It also must have been judged easier to install the bomber's exceptionally tall tails after they had passed under the low factory doors. (Photograph by The Boeing Company; reprinted with permission by The Museum of Flight.)

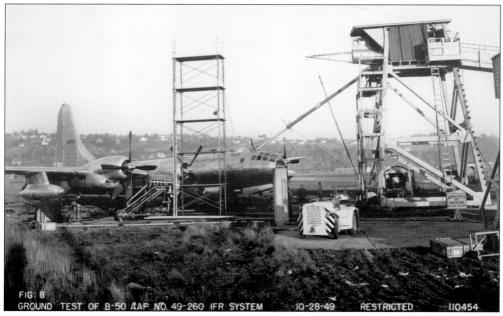

Perfecting the "flying boom" method of aerial refueling, the Boeing Airplane Company erected a mock-up at the north end of the field for testing. Curtiss LeMay, the famously crusty, cigar-chomping U.S. Air Force general, traveled to Seattle to see the system in use. With puddles of gasoline sloshed everywhere on the cement test pad, uncomfortable Boeing officials were finally forced to tell the general it would be in everyone's best interest if he would please put out his cigar. (Photograph by The Boeing Company; reprinted with permission by The Museum of Flight.)

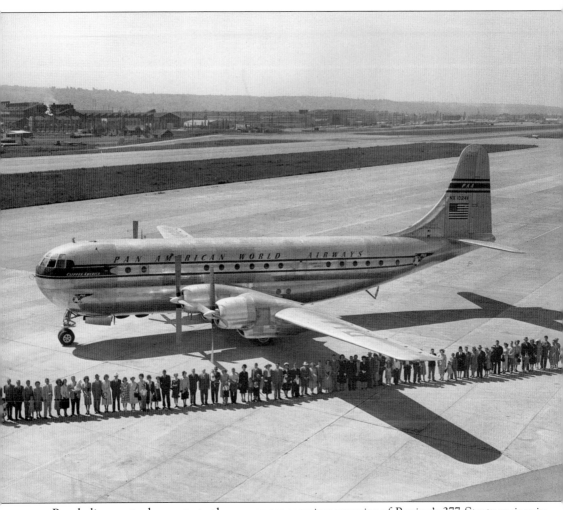

People line up to demonstrate the passenger-carrying capacity of Boeing's 377 Stratocruiser in 1948. Though the $1.5 million airliner had room for 80, the Pan American World Airways version, seen here, was more luxurious. It had accommodation for 61 travelers plus crew. (Photograph by The Boeing Company; reprinted with permission by The Museum of Flight.)

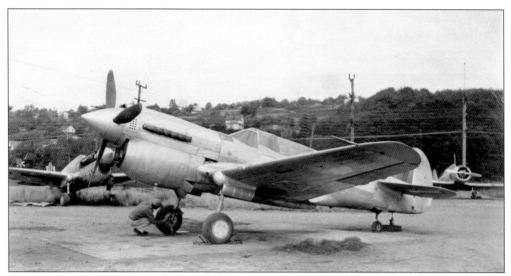

Amid the tar paper shacks and mud puddles on Boeing Field's northeast side, a Curtiss P-40 fighter seems out of place. This is one of about 25 ex-Royal Canadian Air Force warplanes barged down from Victoria, British Columbia, in 1947 and purchased for $50 each. But dreams of making a profit on the machines never really materialized. Most of them were sold, en masse, to a California buyer about a year later. (Author's collection.)

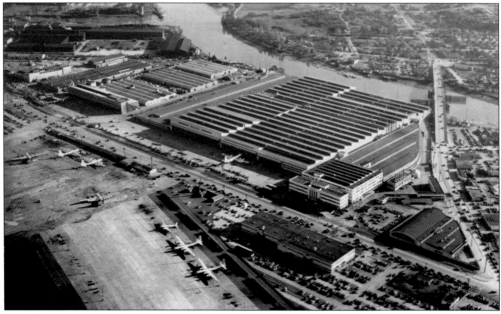

The doors of Plant No. 2 are wide open on a hot summer day in Seattle. The sprawling factory campus stretches for blocks. Outside, a number of new B-50s are parked on the ramp. Note the headquarters building to the north of the plant. (Photograph by The Boeing Company; reprinted with permission by The Museum of Flight.)

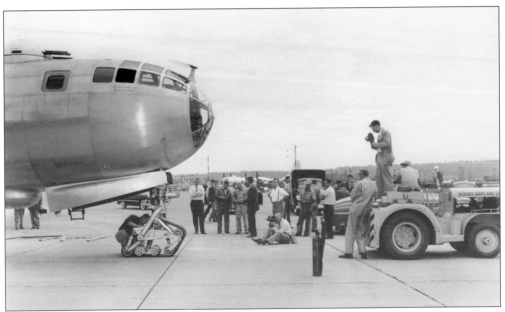

The press moves in close to shoot the tracked landing gear installed on a Boeing B-50 in 1949. The "Flatfoot 50" could land on unprepared runways of dirt, sod, or sand. The gear could handle the weight of a 169,000-pound aircraft, distributing the burden at only 41 pounds per square inch. (Photograph by The Boeing Company; reprinted with permission by The Museum of Flight.)

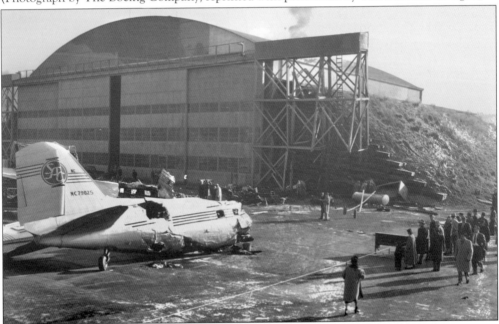

The tail of a Seattle Air Charter Service DC-3 lies near the revetment at the southeast corner of Boeing Field on the morning of January 3, 1949. When the pilot refused to fly the ice-covered plane the night before, the company's owner took over the controls. The crash killed 11 Yale students and the crew of three. Thirteen other passengers were injured. The students were traveling back to the Connecticut school after visiting their homes and families in the Pacific Northwest during the holidays. (Museum of History and Industry.)

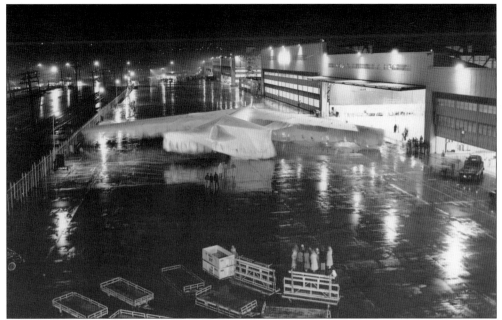

Working for the military is not always fun. When the first B-52 bomber was rolled out of Plant No. 2, the air force insisted it happen at night and under cover. The non-event took place on November 29, 1951. Puzzled Boeing workers wondered who, exactly, they were hiding the plane from. The employees joked, "They are going to have to take the security wraps off to fly it, right?" (Photograph by The Boeing Company; reprinted with permission by The Museum of Flight.)

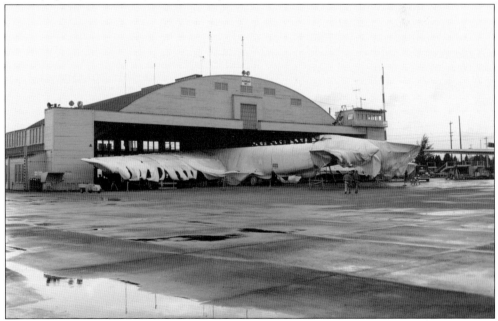

Locals call it the B-52 hangar, but, there is a little problem—a Stratofortress will not fit. The building on the northwest end of Boeing Field was actually built for B-29s during World War II. Here it is used to cover the nose of the big, prototype B-52. (Photograph by The Boeing Company; reprinted with permission by The Museum of Flight.)

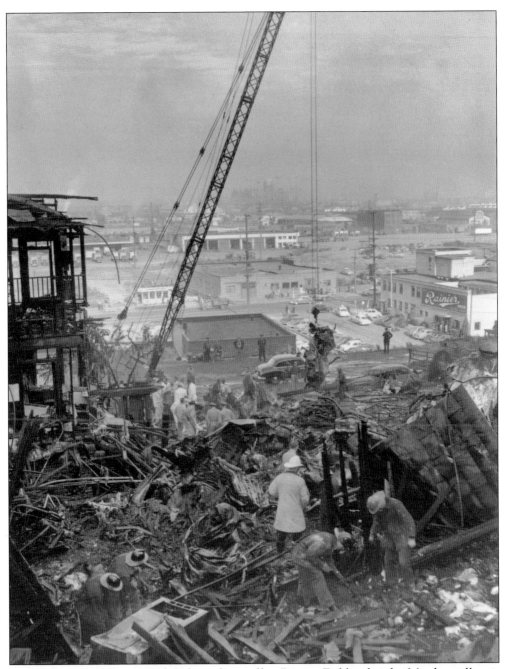

On August 13, 1951, a B-50 bomber taking off at Boeing Field radioed a Mayday call as it struggled for altitude north of the runway. The wing of the four-engine plane glanced off the Sicks' Seattle Brewing and Malting Company building, and the bomber then tumbled into the Lester Apartments on the base of Beacon Hill. The crash and fire killed the crew of six and five on the ground. The apartment building, which was a 500-room brothel during the 1910s, was completely destroyed. Today Interstate 5 passes over the site near the former Rainier Brewery. (Museum of History and Industry.)

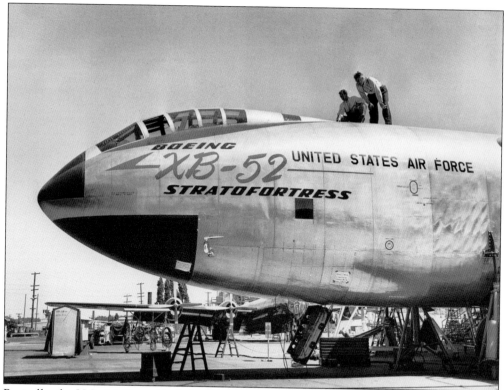

Basically, the U.S. Air Force liked the XB-52, but Gen. Curtis LeMay insisted that the tandem cockpit, similar to the B-47's, be rearranged so that the pilot and copilot sat side by side. Later versions of the plane have a more traditional flight deck. The general, who had flown bombers himself, stated that he believed the side-by-side arrangement increased the effectiveness of the flyers and helped combat pilot fatigue. (Photograph by The Boeing Company; reprinted with permission by The Museum of Flight.)

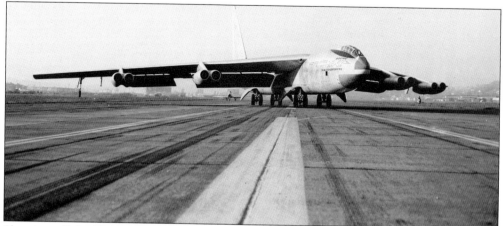

Showing off the XB-52's cross-wing landing gear, the bomber slews sideways on Boeing Field during tests. This helped the massive aircraft be "crabbed" onto the runway in difficult, windy landing situations. Note the small, outrigger, landing gear tires on the ends of the wings and the chase plane following the Stratofortress. (Photograph by The Boeing Company; reprinted with permission by The Museum of Flight.)

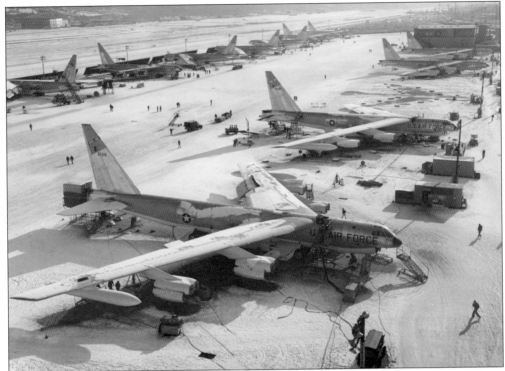

On a rare snowy day in the mid-1950s, flight test work continues on new Boeing B-52Ds. The bare space indicates that one of the bombers is already in the air. The airplanes were made in Seattle and also in Wichita, Kansas. (Photograph by The Boeing Company; reprinted with permission by The Museum of Flight.)

The big KC-97 tankers stayed in service into the 1970s, refueling much faster jet bombers and fighters. In this image, the wide, dual circle fuselage can be seen—excellent for carrying troops, fuel, or cargo. Pilots fell in love with the spacious flight deck area on the airplane. Flyers joked that it seemed like they were sitting in an easy chair in their living room while flying the big aircraft. (Photograph by The Boeing Company; reprinted with permission by The Museum of Flight.)

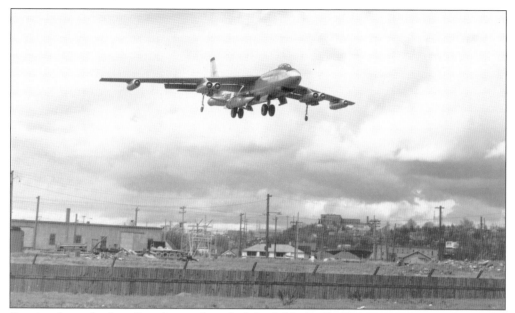

Coming "over the fence" at the north end of the field, this B-47 is carrying a special cargo. A pair of Stratojets built in Wichita, Kansas, were designated YDB-47Es and were able to carry Bell GAM-63 Rascal missiles on the starboard sides of their bellies. When released, the Rascal could be guided by remote control to a target on the ground. (Photograph by The Boeing Company; reprinted with permission by The Museum of Flight.)

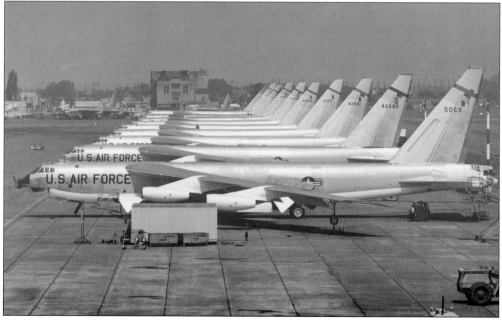

With the steam plant in the background, a line of Boeing B-52s awaits their final touches and flight tests before being delivered to the U.S. Air Force. The first number on the tail of each aircraft shows what year it was ordered—the first one in line was ordered in 1955, the next two in 1954, and the next in 1953. (Photograph by The Boeing Company; reprinted with permission by The Museum of Flight.)

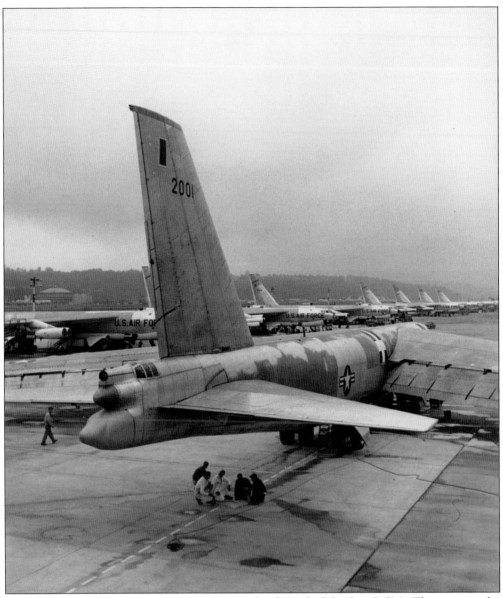

Boeing flyers take cover from the misty rain under the tail of the first B-52A. The cross on the airplane's fuselage was a phototheodolite target for testing equipment. When the airplane was combat ready, the lower bump in its tail cone carried four .50-caliber guns as its defensive armament. (Photograph by The Boeing Company; reprinted with permission by The Museum of Flight.)

Five

MODERN ERA

Alvin "Tex" Johnston had flown jets with Bell Aircraft before coming to the Boeing Airplane Company. Here Boeing's chief test pilot sits on the flight deck of the Dash-80 as it nears completion in Renton. Tex is perhaps most remembered for barrel-rolling the big jetliner over Lake Washington during Seattle's 1955 Seafair hydroplane races. (Photograph by The Boeing Company; reprinted with permission by The Museum of Flight.)

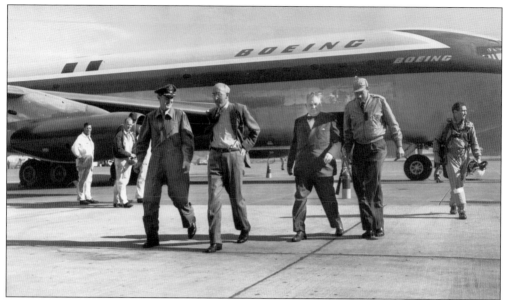

The Dash-80 first flew on July 15, 1954, with Tex Johnston (in the baseball cap) at the controls. The airplane was flown from Renton but landed at Boeing Field after preliminary testing and a photo shoot. The man in glasses, conversing with the U.S. Air Force general, is Boeing's president, William Allen. The airplane would not only be the basis for a new airliner, but also a military cargo and tanker aircraft. (Photograph by The Boeing Company; reprinted with permission by The Museum of Flight.)

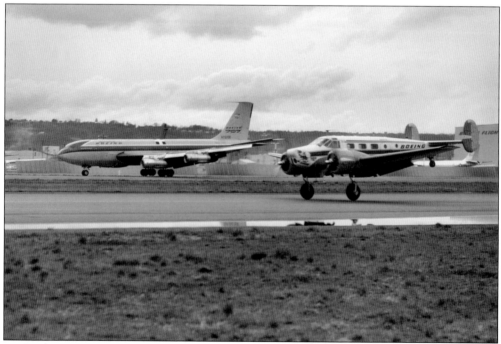

As the Boeing Dash-80 makes a southerly landing on the main runway, a company Beech 18 photo aircraft touches down alongside. Boeing Field's eastern runway primarily handles small planes. (Photograph by The Boeing Company; reprinted with permission by The Museum of Flight.)

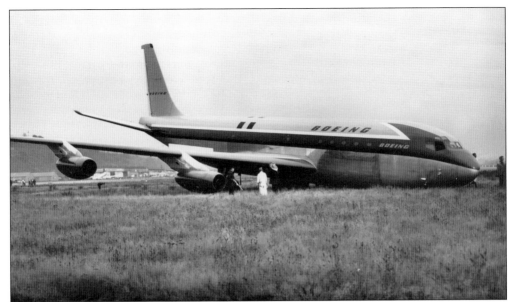

During flight tests, Tex Johnston pushed the Dash-80's brakes to their limit. After one emergency stopping session, he decided to cool the red-hot brakes with a short flight. Upon returning to Boeing Field, Tex discovered the brakes were gone—and that he was rapidly running out of runway. A big, looping turn through the grass at 80 miles per hour was working surprisingly well until the nose wheel hit a pile of discarded concrete. (Photograph by The Boeing Company; reprinted with permission by The Museum of Flight.)

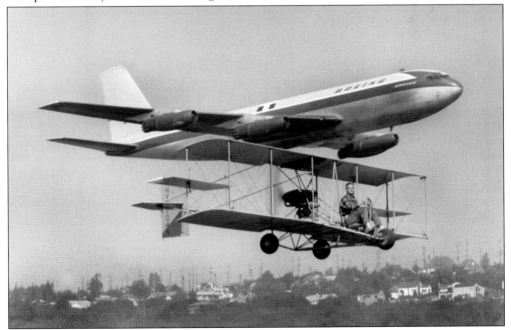

The Dash-80 zooms past a replica Curtiss pusher like it is standing still. The pilot of the wire and cloth machine is Peter Bowers, a local Boeing engineer, airplane builder, and aviation historian. What amazing progress had occurred in the world of aviation in less than 50 years! (Photograph by The Boeing Company; reprinted with permission by The Museum of Flight.)

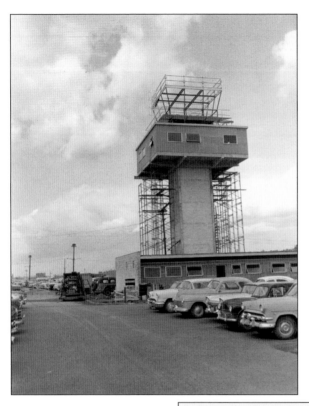

The control tower on the top of the administration building was eventually unsuitable for King County's sprawling airfield. In 1962, a new tower was opened on the opposite (west) side of the runways. This photograph was taken on April 21, 1961, while it was still under construction. (Museum of History and Industry.)

Like everything at Boeing Field, the tower was built on the notoriously unstable and water-soaked fill dirt of the Duwamish River Valley. The tower looked like this from 1962 until after the 6.8 magnitude 2001 Nisqually Earthquake, when the structure was heavily retrofitted with additional supports. (The Museum of Flight.)

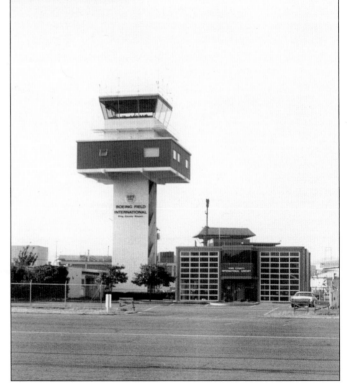

The Dash-80 was the first of a long line of 707 airliners (and C-135 military planes). Here the pioneering airplane sits parked with a trio of the first production 707s, destined for service with Pan American Airways (Pan Am). Pan Am was often the first to acquire new Boeing designs, including the 377, 707, and later the 747. Note the gas tank in the background, formerly at the end of Boeing Field's first runway. (Photograph by The Boeing Company; reprinted with permission by The Museum of Flight.)

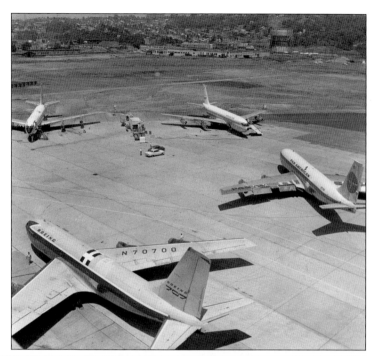

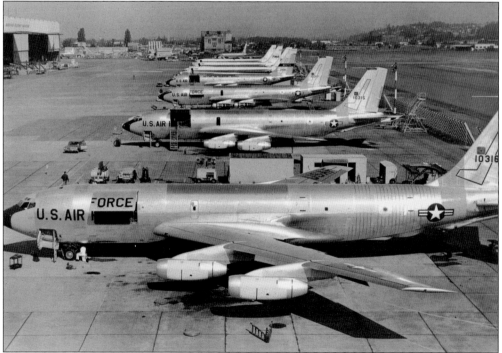

U.S. Air Force KC-135 tanker planes are wing tip to wing tip outside the Boeing Airplane Company's flight center at the northwest end of the airfield. The refueling aircraft could also be used as cargo planes—note the large doors in the sides of their fuselages. Beyond are 707 airliners and a VIP transport. (Photograph by The Boeing Company; reprinted with permission by The Museum of Flight.)

As the Boeing Airplane Company built bigger and faster jets, it needed improved chase planes to keep up. A license-built version of the famous F-86 fighter, this Canadair CL-13B fit the bill. The former Royal Canadian Air Force fighter was photographed before its trip to the paint shop. Boeing used the plane for chase, calibration, and photography work until the early 1990s. (Photograph by The Boeing Company; reprinted with permission by The Museum of Flight.)

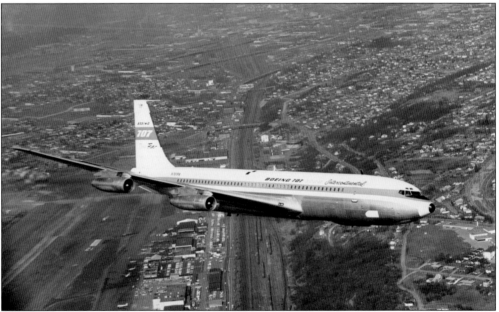

Newer engines and the ability to carry more fuel made the 707-320B able to fly farther than previous 707 models, earning the airliner the *Intercontinental* moniker. This aircraft was built for service with Pan Am, destined to work air routes across the Pacific. For a short time in 1962, the airplane carried this splashier, company paint scheme. (Photograph by The Boeing Company; reprinted with permission by The Museum of Flight.)

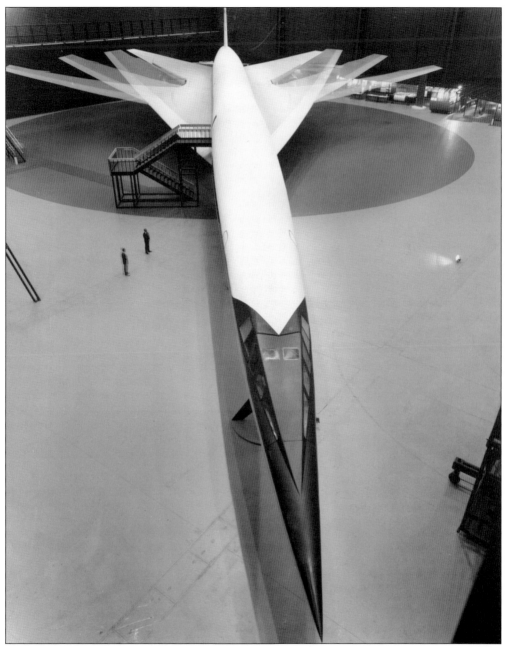

In the days when fuel was cheap and sonic booms were simply the sound of a growing economy and nation, the Boeing Airplane Company was one of the major competitors in the creation of an American SST—Super Sonic Transport. A full-scale mock-up of the swing-wing behemoth was built at Boeing's Developmental Center at the southwest edge of the field. However, the airplane designed to cruise at more than the speed of sound went nowhere fast. (Photograph by The Boeing Company; reprinted with permission by The Museum of Flight.)

The Boeing Developmental Center was known by locals as the "black box," seen here with an illustration of the SST on its side. It cost $23 million and was the largest building of its type when it opened in 1957. In 2006, the black box was painted light gray. (Photograph by The Boeing Company; reprinted with permission by The Museum of Flight.)

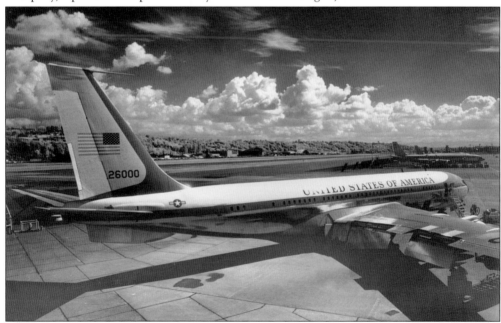

This 707-373C was used by Pres. John F. Kennedy and other VIPs. The airplane had a deluxe interior and special communications equipment. The exterior of the aircraft, designated VC-137C by the military, carried a paint scheme developed by famous designer Raymond Lowey and Jacqueline Kennedy. President Kennedy took his last trip to Dallas, Texas, aboard this aircraft in 1963. (Photograph by The Boeing Company; reprinted with permission by The Museum of Flight.)

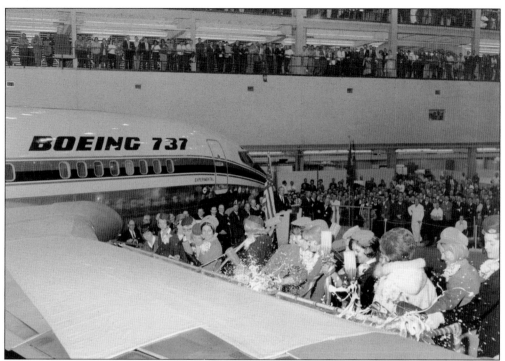

The Boeing 737 airliner was the last aircraft to be made at Boeing's Plant No. 2. The company invited stewardesses from some of the airlines that had ordered the "baby Boeing" to Seattle to christen the first aircraft in 1967. Since then, more than 6,000 of the aircraft have been ordered. (Photograph by The Boeing Company; reprinted with permission by The Museum of Flight.)

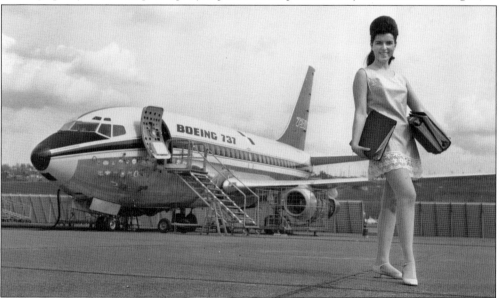

This Boeing press release photograph reads, "Right in step with the small jet theme of Boeing's new 737 program, stenographer Mary Ann Gaviglio, mini-skirted for the occasion, carries the records which helped complete preparations for the jet's first flight in early April [1967]." (Photograph by The Boeing Company; reprinted with permission by The Museum of Flight.)

On April 9, 1967, these two men took off from Boeing Field for the first time in the prototype 737. Test pilots Brien Wygle (left) and S. L. "Lew" Wallick Jr. experimented with the airplane for 150 minutes, testing handling and maneuverability, before landing in Everett. Today the airplane is parked near The Museum of Flight a few blocks from where it was built. (Photograph by The Boeing Company; reprinted with permission by The Museum of Flight.)

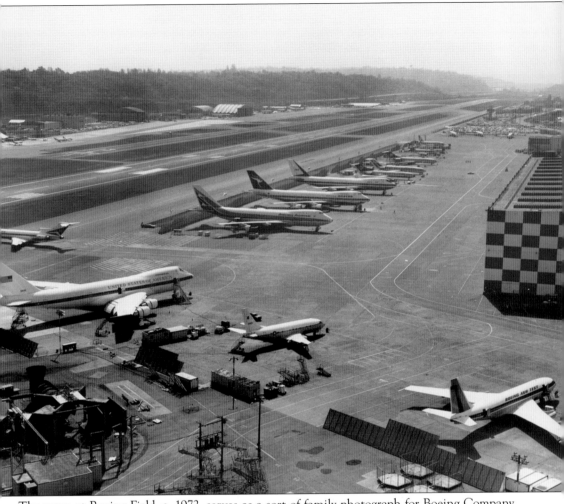

The ramp at Boeing Field, *c*. 1972, serves as a sort of family photograph for Boeing Company aircraft. Careful study reveals a 707, many 727s, a few 737s, and a long line of 747s. The jumbo jet with the boomerang-shaped flash on its tail was the first 747 made; it was retained for flight tests. (Photograph by The Boeing Company; reprinted with permission by The Museum of Flight.)

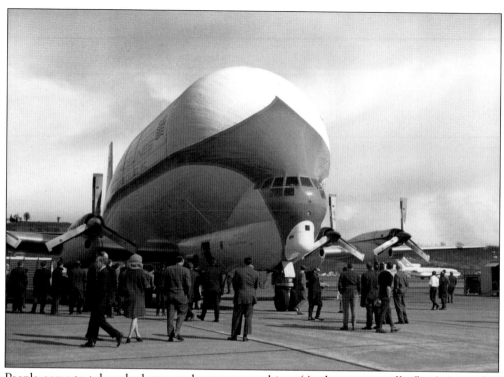

People come to take a look at a truly strange machine. (And yes, it actually flies.) A number of modified C-97/377 type aircraft were acquired by the Aero Spacelines Corporation and enlarged to carry large parts of spacecraft and aircraft. Known as the 377SG, the plane was called the "Super Guppy." (Photograph by The Boeing Company; reprinted with permission by The Museum of Flight.)

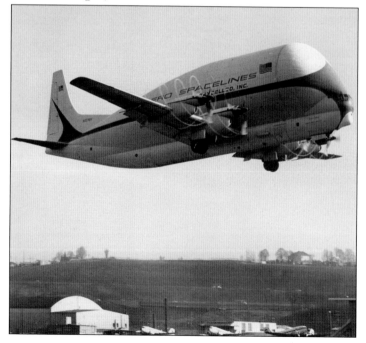

This turbine-powered version of the Super Guppy had 111 feet of cargo space and could heft more than 54,000 pounds. Interestingly, four of the aircraft were used to transport parts of Airbus aircraft in France. The running joke was, "The parts for every Airbus built arrive on the wings of a Boeing airplane!" The airplanes have since been replaced by, perhaps more appropriate, Airbus-built aircraft. (Photograph by The Boeing Company; reprinted with permission by The Museum of Flight.)

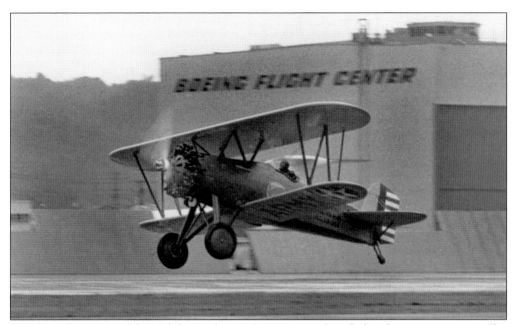

In 1977, a Boeing Model 100 fighter takes to the air on its first flight after its restoration. The airplane hops into the skies at nearly the same place on Boeing Field where it made its first flight in 1929. The airplane was piloted by Boeing test pilot S. L. "Lew" Wallick Jr. Today the plane is on display at The Museum of Flight. (Photograph by The Boeing Company; reprinted with permission by The Museum of Flight.)

Seattle's summertime tradition, Seafair, closes with a weekend of hydroplane races on Lake Washington. But air show fans go to see the U.S. Navy Blue Angels, who have been performing their aerial acrobatics for Seattle spectators since 1952. The group flies from Boeing Field during its practice sessions and shows. Here, in the mid-1970s, all six shiny blue Douglas A-4 Skyhawks land in formation on the wide main runway. (The Museum of Flight.)

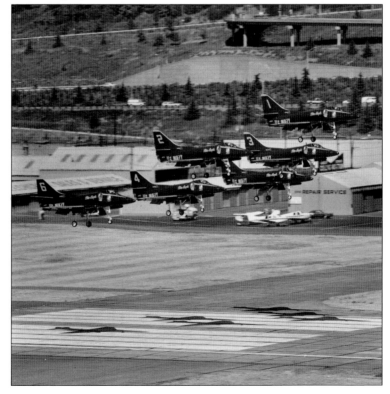

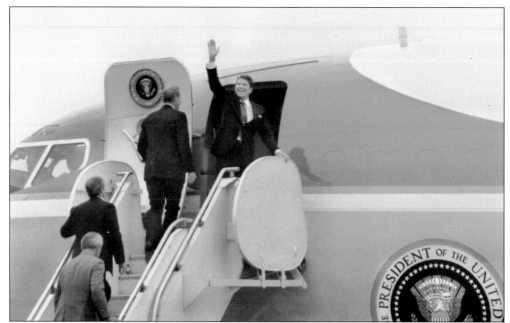

Presidents and VIPs coming to Seattle often fly into Boeing Field because it is more convenient and closer to downtown than Sea-Tac. This image shows Pres. Ronald Reagan boarding Air Force One at Boeing Field after a reelection rally in October 1984. Reagan won in Washington State, as well as nearly everywhere else in the nation. (King County Archives.)

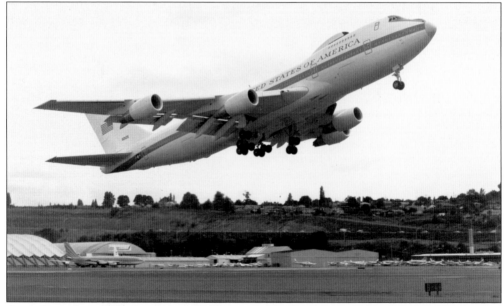

Aircraft watchers claim that Boeing Field is a special place because you simply never know what type of plane will be coming through next. Here one of four Boeing E-4 Airborne Command Post aircraft takes to the skies. When the modified 747s were first introduced in 1974, the media dubbed them "Doomsday Planes"—built to conduct war operations from the air in the event of a nuclear attack. (Photograph by The Boeing Company; reprinted with permission by The Museum of Flight.)

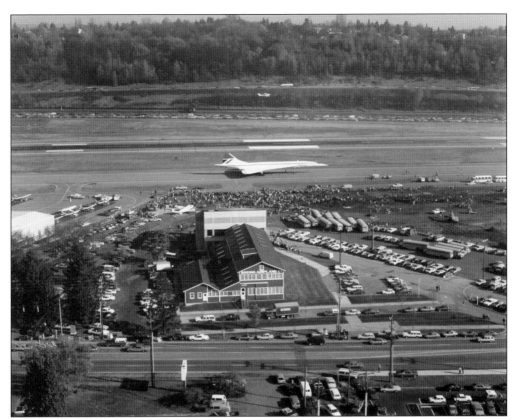

When this image was taken in 1984, The Museum of Flight had recently opened inside the restored Red Barn. The building had been moved onto Boeing Field and placed almost exactly on the spot where the Meadows Racetrack stood earlier in the century. It was a big day at the small aviation museum when a British Airways Concorde supersonic airliner came to Seattle. (The Museum of Flight.)

One critical aspect of Boeing Field that is often overlooked is the airfield's heavy use by the owners of small private airplanes. Galvin Flying Services, which has been on the field almost since opening day, is one of many fixed base operators (FBOs) that offer the general aviation customer a multitude of services, including training, maintenance, amenities, storage, and ground services. (King County Archives.)

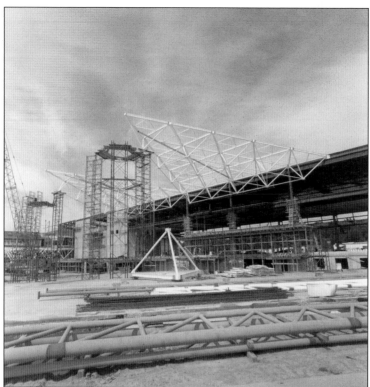

The Museum of Flight's impressive Great Gallery begins to take shape near the southwest corner of Boeing Field in 1987. Local architecture firm Ibsen Nelson and Associates created the six-story-high, clear-span glass and steel building, which is strong enough to hold the load of suspended aircraft. Today more than 23 aircraft hang from its ceiling. (King County Archives.)

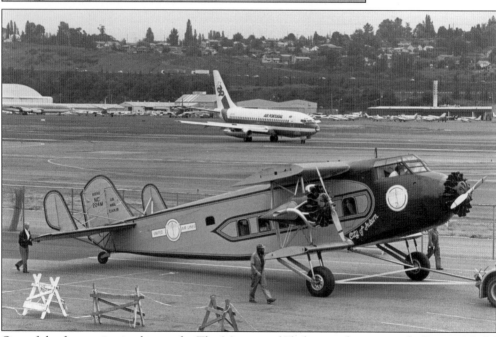

One of the first projects taken on by The Museum of Flight was the rescue of a Boeing Model 80A-1 from a garbage dump in Alaska. It was the only aircraft of its type left in the world. The vintage 80 was brought home to Seattle in 1960. Since the opening of the Great Gallery in 1987, the unique aircraft has been on display at the museum. (The Museum of Flight.)

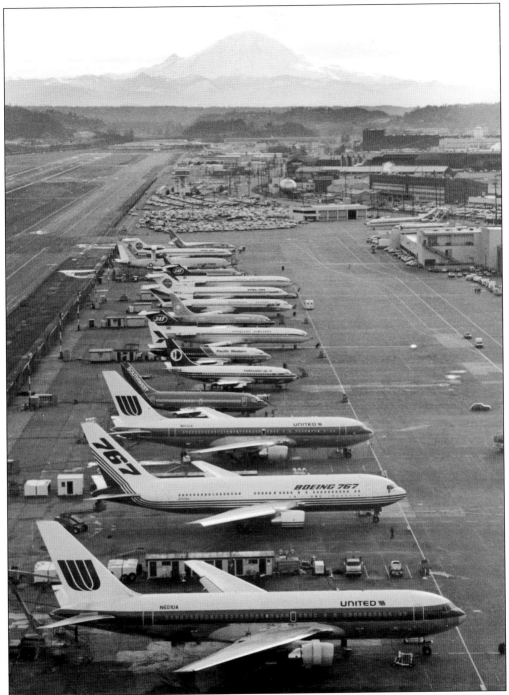

Nearly every day is a busy one at the airport. This photograph was taken in the early 1980s when new 767s, among other aircraft, were on the testing line. But it is a rare day when the clouds part and Mount Rainier can be seen to the south. Across the street, one of two silver circular air tanks is visible. These are for the supersonic wind tunnel. (Photograph by The Boeing Company; reprinted with permission by The Museum of Flight.)

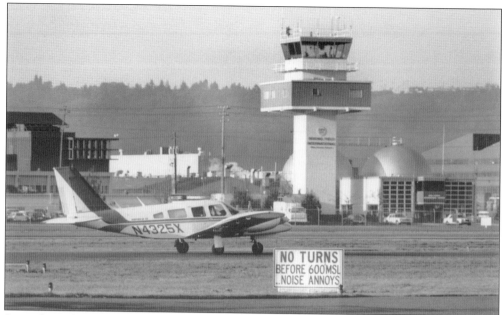

Since the early days, some of those who live around Boeing Field have complained about aircraft noise. Airport officials do their best to encourage flyers to adopt quiet flight procedures and avoid densely populated areas, including West Seattle, downtown, Queen Anne, and Capitol Hill. This sign asks pilots to hold off on their turns, west or east, until at least 600 feet above sea level. (King County Archives.)

Maintaining an airfield the size of Boeing Field is a complex task. King County employs hundreds of workers and fleets of vehicles to keep the 594-acre site, its runways, taxiways, lights, buildings, and systems secure and in top condition. In this image, workers take advantage of a break in the weather and nearly constant stream of air traffic to apply wide white stripes to the south end of the main runway in 1972. (King County Archives.)

Boeing Field's location, closer to downtown Seattle than Sea-Tac, makes the airfield ideal for cargo carriers. UPS, DHL, and FedEx, among others, have used Boeing Field over the years. Here another day unfolds as a long line of packages pours from a cargo aircraft, and workers distribute the boxes to waiting vans and trucks in 1983. (King County Archives.)

An annual air show dubbed Flight Fest was held at Boeing Field for many years in the 1990s, attracting thousands of aviation fans to see static displays on the tarmac and flying machines in the air. Here the public gets a chance to see The Museum of Flight's Boeing B-29 Superfortress bomber up close. The airplane was built during World War II in Renton, southeast of Boeing Field. (The Museum of Flight.)

The Museum of Flight acquired a rare Lockheed M-21 Blackbird from the U. S. Air Force in 1991. Here the men and women who assisted in bringing the speedy spy plane up from California pose with the sun-bleached fuselage at Boeing Field. The airplane has since been restored and parked in the center of The Museum of Flight's Great Gallery. (The Museum of Flight.)

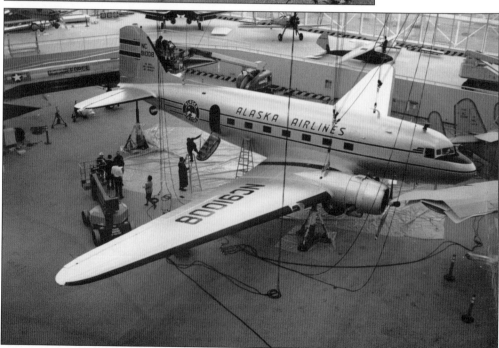

In 1998, The Museum of Flight briefly closed the Great Gallery to rearrange its collection of aircraft. During the rehang, workers moved nearly every aircraft in the 3-million-cubic-foot, glass and steel building. The biggest was this eight-ton Douglas DC-3 passenger plane, which was not only nudged to a new set of hang points, but also lowered down almost to the floor and painted in Alaska Airlines livery. (The Museum of Flight/Eden Hopkins.)

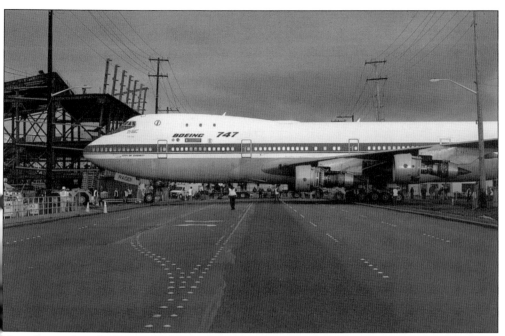

Near the south end of Boeing Field, the first 747 airliner is rolled across East Marginal Way South for display in The Museum of Flight's airpark on February 22, 2003. With its tail temporarily removed, the massive jet airliner was towed under the high tension power lines above the street. (The Museum of Flight.)

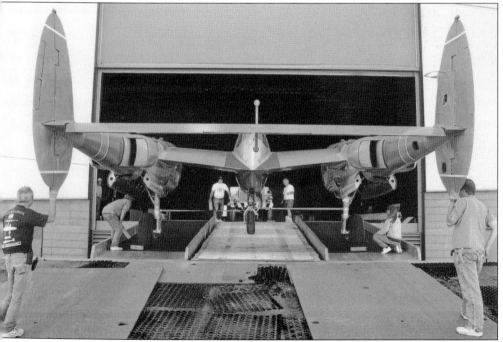

It seems there is always a new airplane being readied for display at The Museum of Flight. Here a Lockheed P-38 Lightning World War II–era fighter is slowly towed up a ramp into the museum's Personal Courage Wing, which opened in 2004. (The Museum of Flight.)

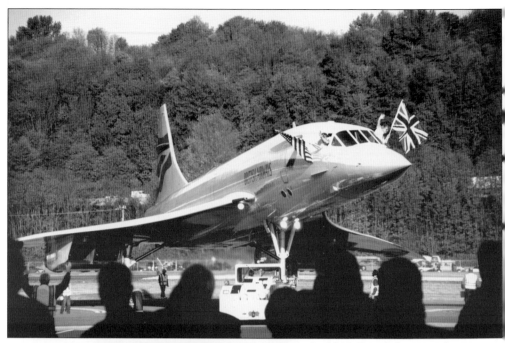

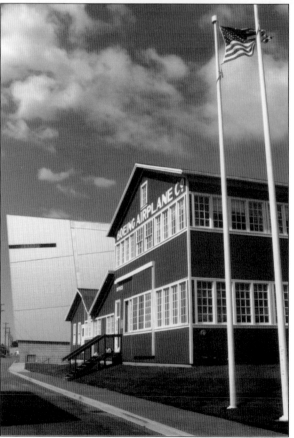

In 2003, Seattle became the permanent home of one of only three Concorde supersonic transport acquired by institutions within the United States. British Airways registration G-BOAG first flew in 1978 and made the last of the airline's commercial flights— from New York to London—in 2003. In a town where Boeing aircraft are ubiquitous, the unique, European-built Concorde attracts many curious admirers. (The Museum of Flight.)

Old and new aircraft stand side-by-side on The Museum of Flight's campus at Boeing Field. The Red Barn, built in 1909, was barged up the Duwamish River and functioned as the museum's only exhibition space from 1983 to 1987. The Boeing Airplane Company's first airplane-building facility is today on the National Register of Historic Places. Next door is the museum's newest facility, the windowless Personal Courage Wing, containing World War I and World War II fighter aircraft. (The Museum of Flight.)

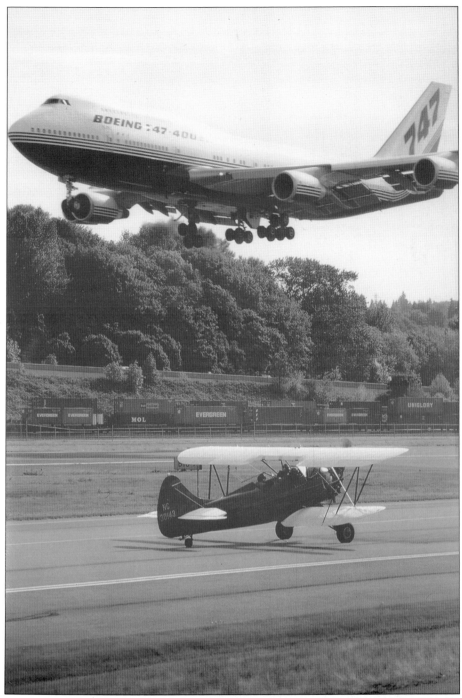

Here is a taste of the varied types of aircraft that can be seen on Boeing Field today. The Boeing 747-400ER has a takeoff weight of 910,000 pounds. The other aircraft is a Waco UPF-7 biplane owned by Olde Thyme Aviation. It weighs 2,600 pounds. When this photograph was taken in the fall of 2002, the 747 was returning from a flight test. The Waco was taxiing out to shuttle tourists on a short sightseeing trip over downtown Seattle. (Joe Walker.)

www.arcadiapublishing.com

Discover books about the town where you grew up, the cities where your friends and families live, the town where your parents met, or even that retirement spot you've been dreaming about. Our Web site provides history lovers with exclusive deals, advanced notification about new titles, e-mail alerts of author events, and much more.

MADE IN THE

Arcadia Publishing, the leading local history publisher in the United States, is committed to making history accessible and meaningful through publishing books that celebrate and preserve the heritage of America's people and places. Consistent with our mission to preserve history on a local level, this book was printed in South Carolina on American-made paper and manufactured entirely in the United States.

This book carries the accredited Forest Stewardship Council (FSC) label and is printed on 100 percent FSC-certified paper. Products carrying the FSC label are independently certified to assure consumers that they come from forests that are managed to meet the social, economic, and ecological needs of present and future generations.

FSC
Mixed Sources
Product group from well-managed forests and other controlled sources

Cert no. SW-COC-001530
www.fsc.org
© 1996 Forest Stewardship Council

Find Your Place in History.